© Published by the National Gallery of Australia, GPO Box 1150, Canberra, ACT 2601, 1992.

Cataloguing-in-publication data

National Gallery of Australia.
 An introduction to the National Gallery of Australia.
 ISBN 0 642 13027 2.
 1. National Gallery of Australia — Catalogs. 2. Art museums — Australian
 Capital Territory — Canberra — Catalogues. I. Title.
708.99471

Co-ordinating editor: Hester Gascoigne
Written by curators of the National Gallery of Australia
Edited, designed and produced by the Publications Department of the National Gallery of Australia

Typeset by Brown & Co. Typesetters, Canberra
Colour separations by Prepress Services WA Pty Ltd
Printed by Lamb Printers Pty Ltd, Perth

(cover)
National Gallery of Australia, Canberra
(endpapers)
Sculpture Garden, National Gallery of Australia

AN INTRODUCTION TO THE
NATIONAL GALLERY
OF AUSTRALIA

NATIONAL GALLERY OF AUSTRALIA

The Australian National Gallery was created as a place for all people and all seasons — a place to behold the past, the present and the future with family and friends from home and overseas.

Home of the National Collection of art, this gallery is very young in comparison with its international counterparts. Although the Commonwealth Government has been acquiring art since 1911, serious collecting of Australian art did not begin until 1967, followed by international art in 1972.

The building in which these collections are housed is the result of a competition held in 1968 and won by Edwards Madigan Torzillo Briggs International Pty Ltd, led by design architect Colin Madigan. Construction began in 1973 on a two-hectare site by the shores of Lake Burley Griffin, and the 23-metre-high building was completed in 1981.

Occupation, fit-out and installation of displays continued until the ceremonial opening on 12 October 1982 by Her Majesty Queen Elizabeth II. The Gallery opened to the public the next day.

Since its opening the Gallery has become an integral part of Australian cultural life and the international art world. It has initiated and hosted major exhibitions, and lent works to similar exhibitions in Australia and overseas. It is a recognised source of art scholarship.

The core of the National Collection is, of course, the Australian collection. It tells the story of European settlement over the past two hundred years. Displays combine paintings, sculptures, drawings and watercolours, prints and photographs, folk and popular arts, as well as decorative arts in all media. They have helped many visitors gain an understanding of the history and development of this country through its art.

The oldest art tradition in Australia is that of the country's original inhabitants and their descendants. Aboriginal art is not a static relic of a bygone era but a vital expression of current human concerns. Aboriginal artists may work in either traditional media or adopt new techniques, but the values permeating their art are consistently and distinctively Aboriginal. Their achievements are well documented in the National Collection.

The National Collection affirms Australia's location in the Pacific region by its small but excellent representation of the art produced by our Oceanic neighbours. It also includes a range of material from further afield — works originating in Africa and Pre-Columbian America.

The Asian collection introduces Australian audiences to brilliant achievements in the visual arts of the many Asian and Islamic cultures. Although small, these collections embody some of the great social and national themes of Asian history.

The International collection parallels the Gallery's holdings of Australian art over the past two hundred years. It contains paintings, sculptures, photographs, prints, drawings, illustrated books and decorative arts, including theatre arts and fashion. The collection concentrates on the achievements of European and American artists, and finds its strengths in the twentieth century. It represents the major schools and movements in art from 1850 to the present and includes a small but historically significant collection of European art before 1850.

Sculptures from the collections are on show in the sculpture garden, which is designed to display up to fifty works in 'outdoor rooms' created by native trees and shrubs, a slate-paved court and a marsh pond.

Behind the scenes at the Gallery a professional team is busy developing the National Collection and providing access to the works through a variety of services for visitors.

In the Conservation department the most recent scientific methods are used to monitor the condition of art in the Gallery's care and, where necessary, to restore and repair damaged pieces. The Registration department is responsible for the safe storage and location of tens of thousands of

works, as well as for co-ordinating the transportation and handling of hundreds of incoming and outgoing works each year. Staff photographers undertake all the Gallery's record and reproduction photography. The security services ensure the safety of the National Collection, the Gallery staff and visitors.

The Gallery increases public access to the collection in a number of ways. The Gallery's in-house and travelling exhibitions programs are serviced by specialist exhibition staff. The Research Library is an essential resource for Gallery staff and scholars throughout Australia, with reference material covering the scope of the collection. The Education department provides public programs based on the premise that art is for all people of all ages. The Gallery's Marketing section is responsible for enhancing knowledge of the collection by producing publications such as books, catalogues, room brochures and magazines, as well as products that include calendars, cards, posters and jigsaws.

The Gallery Association is an opportunity for Members of the Gallery to support the institution while receiving a variety of membership benefits. The Foundation assists with the acquisition of works of art and secures donations to fund activities and future exhibitions.

Since it opened in 1982, the Gallery has worked consistently to establish a point of national focus in Australia's cultural life. Its vision is one of an expanding institution which enhances the nation's cultural life by bringing to Australians the best of the art of the country, its region and its time.

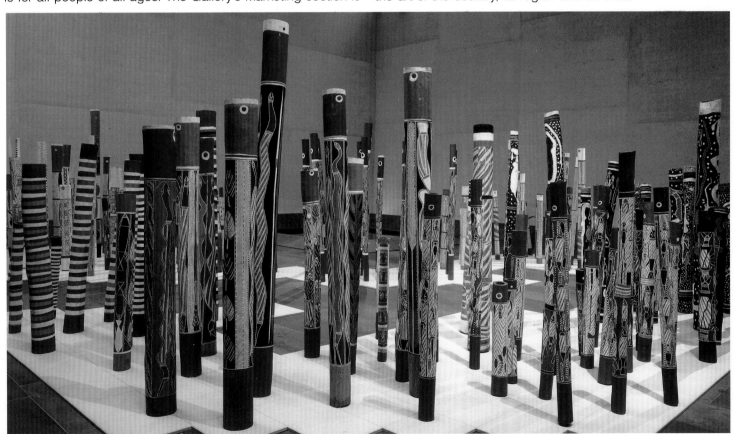

Ramingining artists, Aboriginal Memorial, 1988

The Australian art displays date from the time European ships first explored the South Pacific to the present day.

They contain amateur and formal art and include paintings, sculptures, photographs, prints, decorative arts and illustrations. Items can be as varied as furniture fashioned by bush carpenters, a complex bureau in exotic timbers constructed by an unknown Chinese craftsman, and architect-designed chairs that were standard furniture in a university college not so long ago. Amid paintings in the grand tradition there are also more informal works, such as a portrait painted in Kowloon from a Melbourne photograph and paintings of fish and flowers that were produced by a sign-painter to pay his drink and gambling debts.

In the history of our nation there have been many expressions of an Australian style, in behaviour, dress and design. In fact the typical Australian has been a migrant from another continent who adopts an Australian style. The firstcomers were the Aborigines, who commemorated their ancient voyages of discovery with traditional history paintings. One such is Wandjuk Marika's painting, on bark, of a perilous ocean voyage. Since the end of the eighteenth century, successive waves of people, including British, Chinese, Germans, Italians, Greeks and Vietnamese, have migrated here. One of the early migrant ships under sail brought artist John Glover to Australia in 1830. Glover showed the vessel becalmed in tropical waters — an image that appears untroubled to today's viewer. To travellers of Glover's time, however, it signalled the possibility of a disaster at sea such as that which befell the 'painted ship upon a painted ocean' in Coleridge's famous epic *The Rhyme of the Ancient Mariner*.

The story of migration in the hope of making a new life in a new country has not changed since the early nineteenth century. European migrants on a liner to Sydney were as apprehensive and expectant in 1966 as the first Aborigines who rowed their small craft over shark-infested waters to the land of kangaroos.

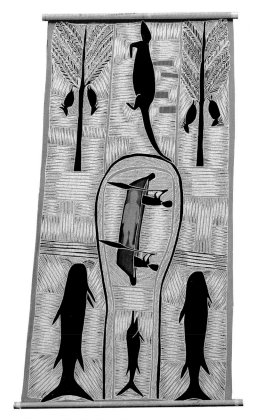

1. **Wandjuk Marika**, Djang'kawu going to Yalangbara, 1986

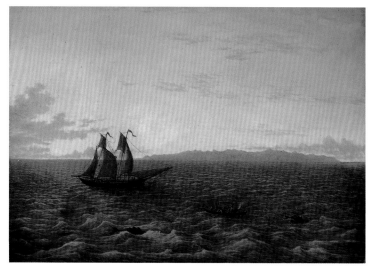

2. **John Glover**, The Island of Madeira, 1831

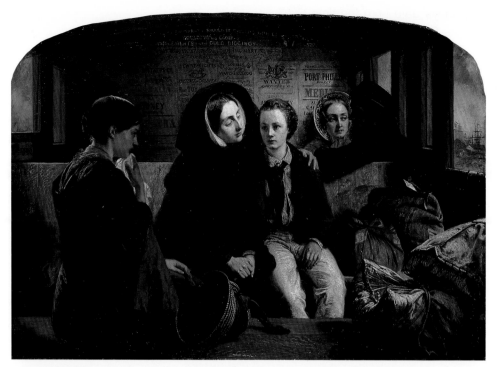

3. **Abraham Solomon**, Second Class — the parting: 'Thus part we: rich in sorrow parting poor', 1854

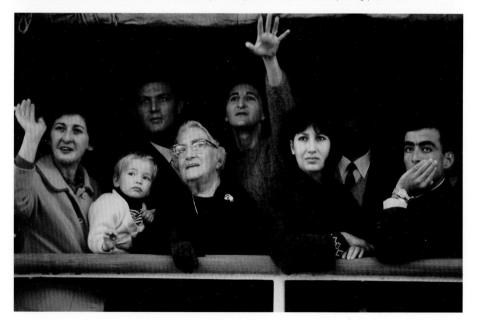

4. **David Moore**, European migrants arriving in Sydney, 1966

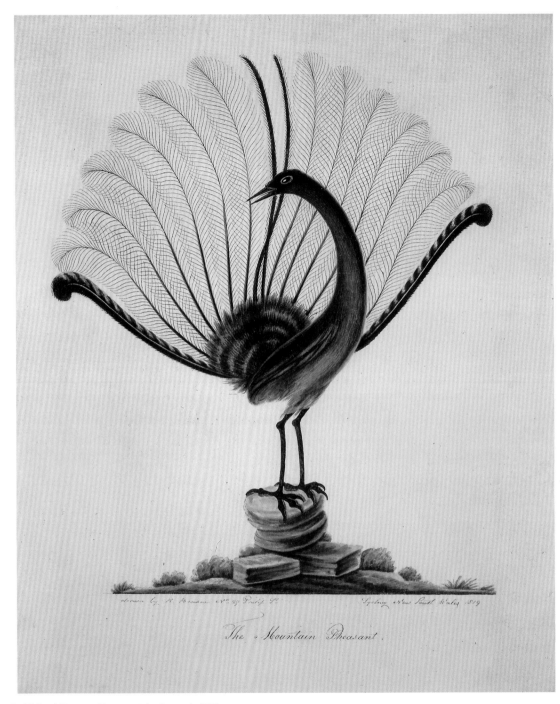

5. **Richard Browne,** The mountain pheasant, 1819

Europeans arriving in Australia early last century brought with them a taste for elegant natural forms. Richard Browne, who like many of our early artists came here as a convict, was able to exploit interest in the colony's novel fauna by painting and selling versions of the lyrebird, one of his favourite subjects. Noted for its fine voice, powers of mimicry and the spectacular displays of the males' long, lyre-shaped tails, the lyrebird was known to Browne and his contemporaries as 'the mountain pheasant'.

In this version the lyrebird is presented like a natural history drawing, but the artist's interest is as much aesthetic as scientific. The sweeping filigreed beauty of the tail feathers set behind the curve of the bird's neck is a prominent and charming feature of this delicate drawing.

That same love of pure design is found in the cedar sofa, made in Tasmania some thirty years later. This, too, embodies lyre-curves and a sense of satisfying, but simple, symmetry. It is made from Australian native cedar, the favourite timber for joinery and furniture-making in the first half of the nineteenth century. The sofa is one of many pieces in the collection which tells the story of Australian decorative arts and design style.

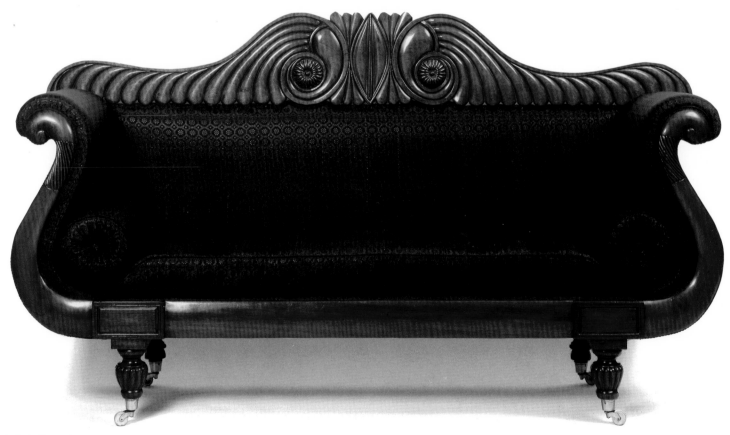

6. **Sofa**, Tasmania, c.1840

A European artist depicting Aborigines and an Aboriginal artist depicting the invaders of his world ... Benjamin Duterrau painted the meeting of George Augustus Robinson, a white man, and Timmy, one of the Aboriginal people Robinson persuaded to leave the bush and enter the European settlements established in the 1830s. Duterrau considered Robinson a contemporary hero and a fitting subject for a record of significant events of his time. Duterrau's art was characterised by its high-mindedness, but he was a poor technician. Most of his paintings, like this one, have undergone extensive expert restoration in recent years.

In contrast is a work of a very different kind, a drawing from a sketchbook made in the 1880s or 1890s. The artist is Tommy McRae, an Aborigine from the Upper Murray area. Besides occasional drawings of men in European dress and Chinese people, Tommy McRae's art celebrates traditional Aboriginal life — hunting and ceremonial gatherings. He remembered the richness of his culture when he was a child, before Europeans came with their animals, axes, guns and houses. McRae always worked in pen and ink, and usually in sketchbooks which buyers sought because of the artist's keen eye and sense of characterisation.

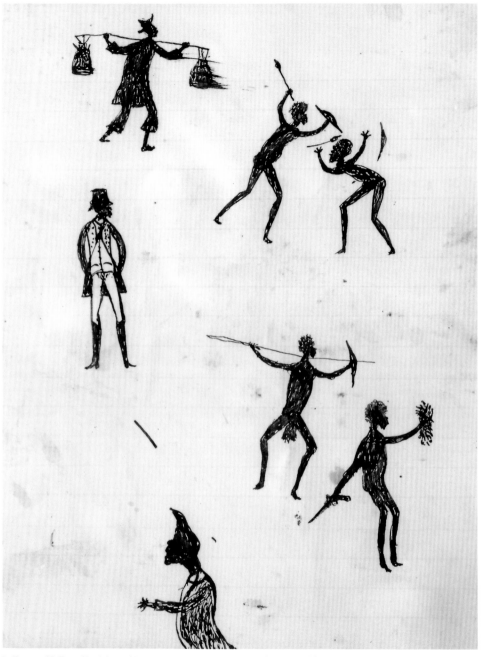

7. **Tommy McRae**, Aborigines, Chinese and a man in European dress, *c.*1890s

8

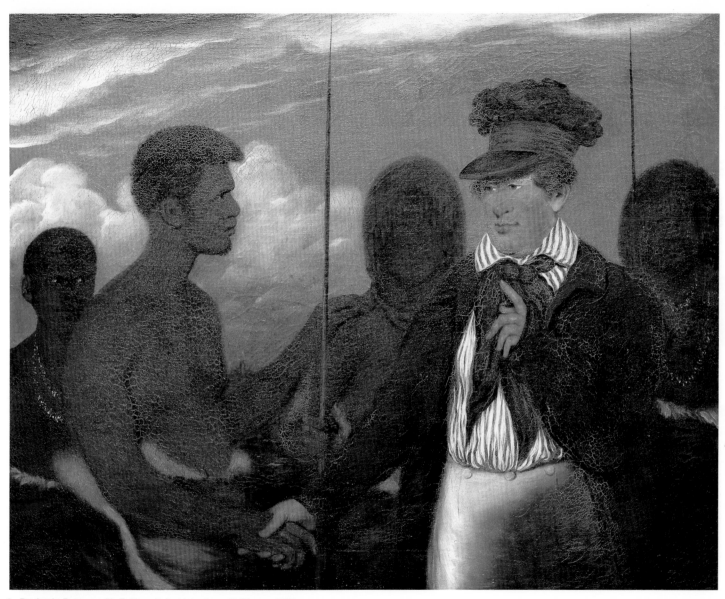

8. **Benjamin Duterrau**, Mr Robinson's first interview with Timmy, 1840

9. **Arthur Streeton**, The selector's hut: Whelan on the log, 1890

10. **Harden S. Melville**, The squatter's hut: news from home, 1850–51

The Australian landscape has dominated our history, mythology and art.

A recurrent theme in nineteenth-century illustration was the arrival of the overseas post. Reading news from home, the squatter in his primitive hut (and viewers of the image) were reminded of the gentle life of England, while outside the hut was the alien, sunstruck Australian landscape. This bleached and inhospitable image was well established when Harden Melville painted *The squatter's hut: news from home*, 1850–51. Forty years later Arthur Streeton used the same sunburnt imagery in *The selector's hut: Whelan on the log*, 1890. Like Melville, he did not paint in the outback. Streeton painted his 'selector' in the Melbourne suburb of Heidelberg, where a farm had recently been subdivided into building blocks.

A comfortable image of farming was finally produced after the First World War, when George Lambert painted the quintessential image of prosperity, *The squatter's daughter*, 1923–24. This was one of many paintings showing Australia as a pastoral paradise remote from the devastation of battle.

11. Cockatoo roof finial, New South Wales, c.1920

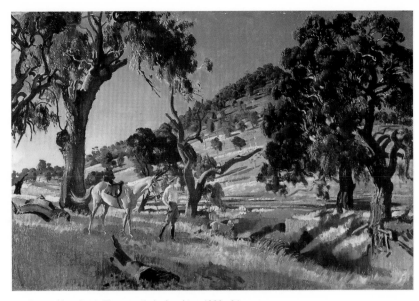

12. **George Lambert**, The squatter's daughter, 1923–24

13. Chair, New South Wales, c.1900

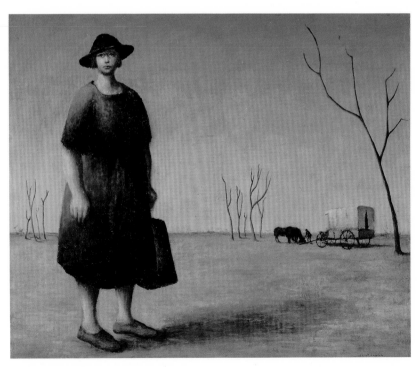

14. **Russell Drysdale**, The drover's wife, 1945

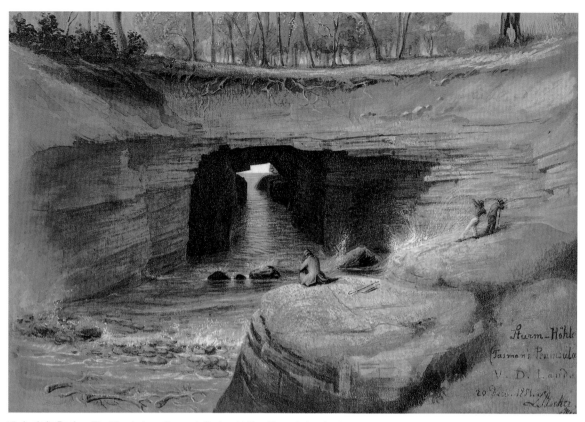

15. **Ludwig Becker**, The blow hole on Tasman's Peninsula, Van Diemen's Land, 1851

Tom Roberts, Arthur Streeton and Charles Conder are perhaps the best known of all Australian artists to the general public. Less familiar are the equally 'Australian' paintings produced as early as the 1830s.

For Tom Roberts, a landscape offering clarity of light, sheer rock and river water becomes the near-perfect foil for an image of human and natural drama. He uses the extraordinary power of the landscape to camouflage the shoot-out between two bushrangers. Explosions of smoke that signify gunshot impact become part of the Australian bush, their small blaze lost against the forceful rock face. Ludwig Becker's blowhole is spectacular too, the landscape overwhelming the figures it contains.

In both pictures the viewer takes up the position of observer — in the same place one imagines the artist — and watches the spectacle of the setting and the action. The atmosphere of both places is disturbing. It is easy to remember the feeling of the sun beating down on flat, grey stone or the cool spray of the ocean and the fecundity of exposed dirt, tree roots and rock strata.

These men are protected and enclosed. Perhaps nature is a woman.

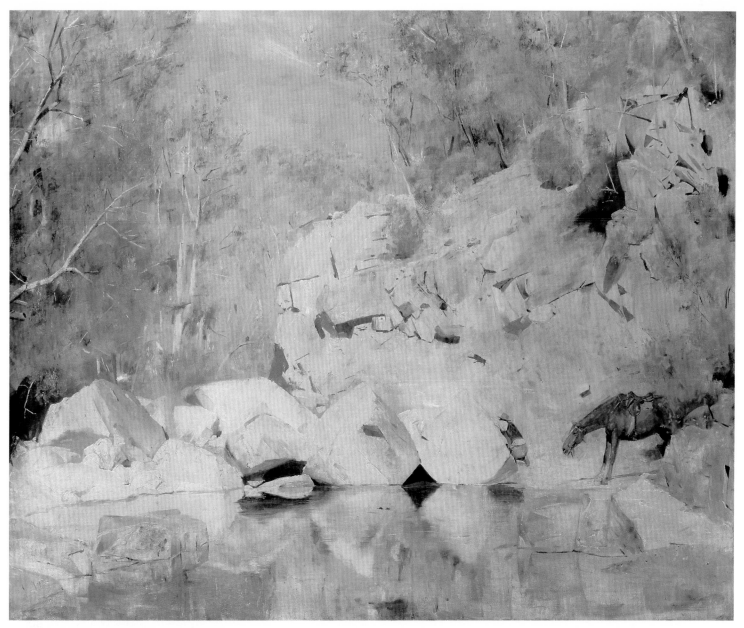

16. **Tom Roberts**, In a corner on the Macintyre, 1895

These interpretations of the Australian landscape span 160 years. Each of the artists, Joseph Lycett, Grace Cossington Smith, Eugene von Guérard and Imants Tillers, has set out to represent the landscape accurately. However, their objective was larger than mere characterisation of a particular place. They attempted universal language. Joseph Lycett described landscape forms and trees schematically one hundred years before Grace Cossington Smith produced surprisingly similar results. Lycett's recipes had been formulated in the late eighteenth century to achieve a 'picturesque' realism. Cossington Smith was guided by modern theories about the dynamic rhythms of natural growth. The unity of her watercolour indicates the thought she put into composition.

The German artist Eugene von Guérard made drawings from Mount Kosciusko during a scientific expedition there in 1862. His definition of the landscape is of geological unity and God-given order. In this picture, natural stone ramparts guard an outlook from above. Humankind seems insignificant. The artist aims to depict the view seen by an all-powerful creator rather than photographic realism.

Imants Tillers's huge version of von Guérard's painting is an image of doubt. In his art Tillers regularly chooses an apparently authentic image — the more authentic the better — in order to observe that it is an interpretation and, as such, untrue.

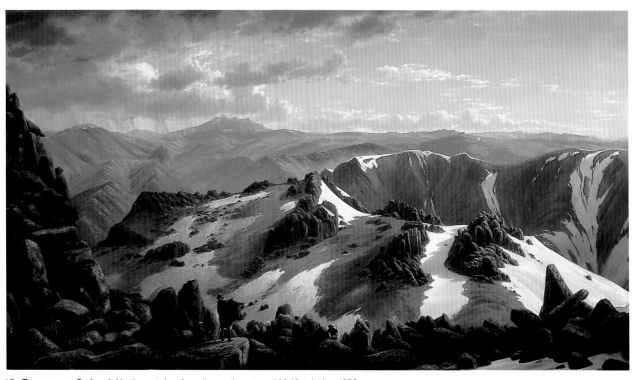

17. **Eugene von Guérard**, North-east view from the northern top of Mt Kosciusko, 1863

18. **Joseph Lycett**, Beckett's Fall on the River Apsley, 1825

19. **Grace Cossington Smith**, The Eastern Road, Turramurra, *c.*1926

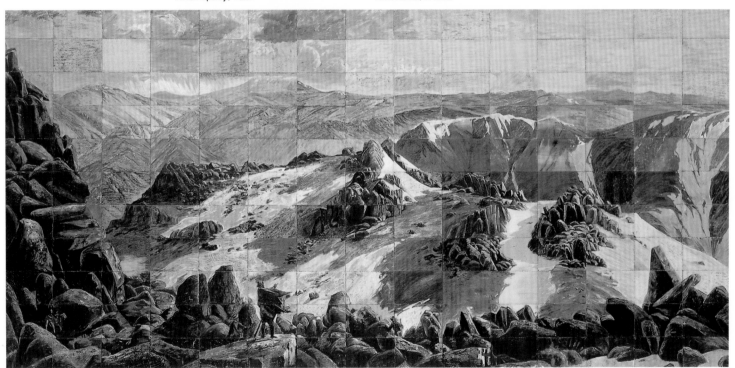

20. **Imants Tillers**, Mount Analogue, 1988

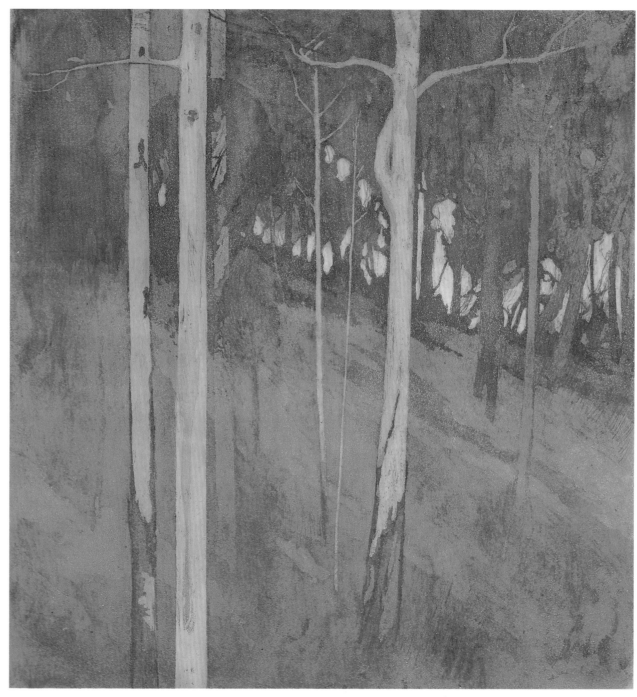

21. **Jessie Traill**, Goodnight in the gully where the white gums grow, 1922

22. **Fred Williams**, Red trees, 1962

In order to portray the Australian landscape successfully, artists have had to understand all of its subtleties — its diversity, peculiarities and nuances. Since the early years of Australian art, the gum tree has been one of the most popular images for landscape artists.

The gums shown in these two works are not the typically gnarled 'heroic' gum trees. Jessie Traill and Fred Williams have reduced the bush and the trees to their simplest forms. Tall and elegant, the gum trees dominate *Goodnight in the gully where the white gums grow*, 1922, Traill's romantic print. The bush provides an air of mystery as it merges deep into the background.

Fred Williams's watercolour *Red trees*, 1962, focuses on the dominating tree trunks, while in the background the bush is an ambiguous blend of colours.

Williams and Traill have captured the abstract qualities of the landscape and, in doing so, its essence.

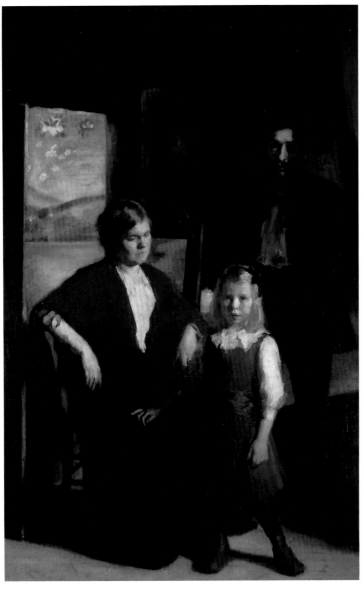

23. **Max Meldrum**, Family group, 1910–11

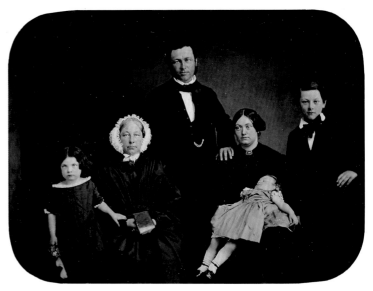

24. **Thomas Glaister**, The Moore family, c.1860

Few of the early photographers lavished as much care on the size, quality and colouring of their portraits as Thomas Glaister, an American who worked in Australia in the 1850s. In this unusually large ambrotype, measuring 25.6 x 30.6 cm, *The Moore family*, c.1860, are on exhibition. It is a subtle catalogue of affluence and aspiration. The boy standing is the grandfather of the contemporary Australian photographer David Moore, whose image of migrants arriving in Sydney a century later is shown on page 5. As exposure times for early photographs were quite long, they could be as formal as painted portraits. If a visit to the studio could not be timed for baby's sleep, a dose of laudanum would produce the requisite stillness.

The family group shown in Max Meldrum's painting is his own. The artist's face draws our attention, despite his position in shadow behind his wife and daughter. Meldrum's technique was in the tradition of old master portraits, with strong contrasts of light and shadow often used to emphasise character rather than wealth and position.

By contrast, in Aboriginal society naturalistic likenesses are not important. Family relationships are described through their connection to the land. Inherited designs and totem symbols relate complete histories of the family back into the time of creation. Pompey Japanangka Martin's painting depicts men and women of two kinship groups who share inherited custody of the country. The people, depicted as U-shapes, are making camps and lighting fires (concentric circles). They collect ngalyipi or bush vine and perform ceremonies associated with Janyinki, west of Alice Springs.

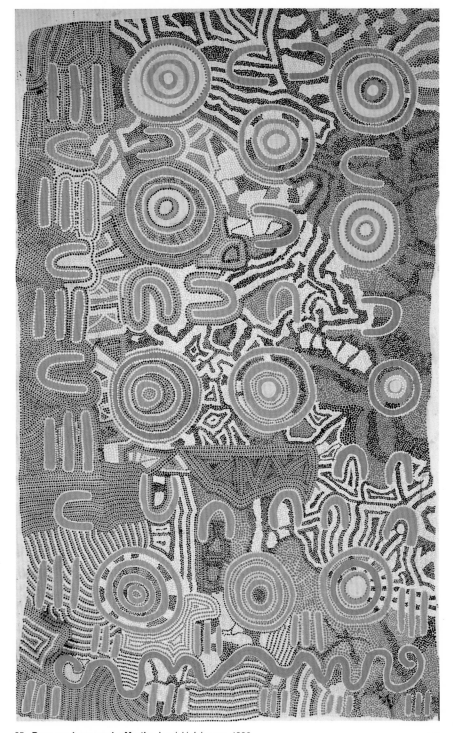

25. **Pompey Japanangka Martin**, Janyinki Jukurrpa, 1986

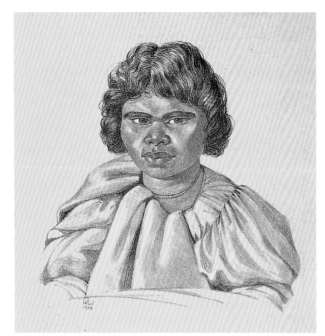

26. **Charles Rodius**, Tooban, ginn or wife of the chief of Shoalhaven tribe, 1834

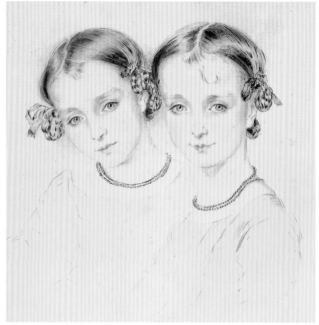

27. **Thomas Griffiths Wainewright**, The Cutmear twins, Jane and Lucy, c.1842

28. **Seham Abi-Elias**, Untitled, 1984

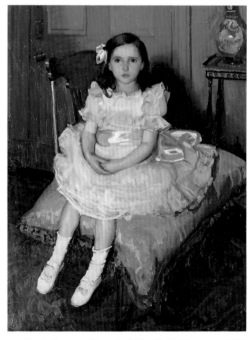

29. **Hugh Ramsay**, Portrait of Miss Nellie Patterson, 1903

Images of childhood abound in Australia, indicating the importance we place on family. They also reveal aspects of the artist and the age in which they were produced.

Convict artist Charles Rodius was one of those who drew Aboriginal people in the 1830s, aware of their tribal destruction and threatened existence. In contrast, the delicate portraits of the Cutmear twins, Jane and Lucy, were drawn in 1842 by another convict artist, Thomas Wainewright, a decadent character in Tasmanian colonial society.

Dame Nellie Melba commissioned the portrait of her niece, *Miss Nellie Patterson*, 1903, from French-trained artist Hugh Ramsay. He painted this portrait of the young girl in her party dress in a style of considerable bravado.

John Brack chose no such special occasion for his portrait *Third daughter*, 1954. All spikey, she stands defiantly, mouth set and fists clenched, in one of those everyday family situations. Even so, it is a tender portrait by an obviously loving father.

If *Third daughter*, 1954, represents the cold-war child of the 1950s, the Lebanese-born Sheham Abi-Elias's untitled portrait of a child may represent the youth of the 1980s. It is an image of dislocation — a child caught between two cultures.

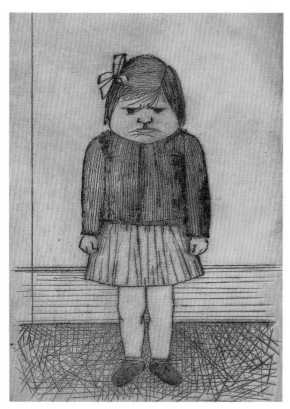

30. **John Brack**, Third daughter, 1954

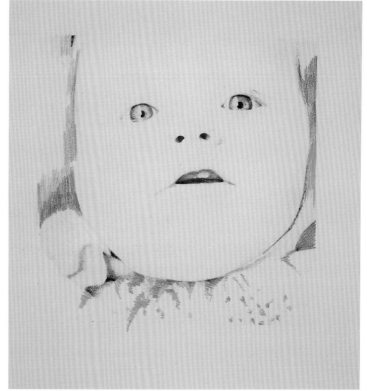

31. **Micky Allan**, Babies, 1976

21

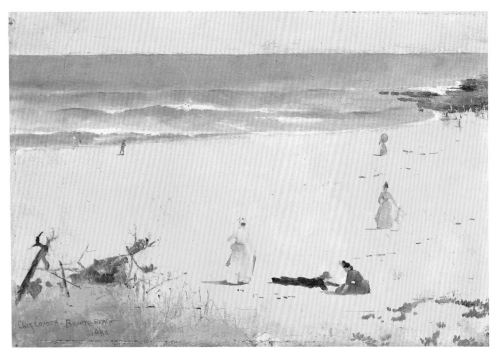

32. **Charles Conder**, Bronte Beach, 1888

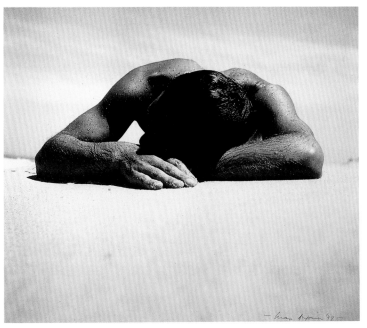

33. **Max Dupain**, The sunbaker, 1937, printed 1970s

This century beach images have become synonymous with Australia. Charles Conder, who belonged to two cultures — English and Australian — shows a casual grouping of graceful females on Sydney's Bronte Beach. Bathing was permitted but the gentlefolk in Conder's many beach scenes of the late 1880s enjoyed nature fully clothed and on cooler days. The scene could easily be from Europe. It uses the free brushwork of French Impressionism to capture the fleeting atmosphere. The image also attests to the recreational use of the landscape, which increased in the 1880s.

By the 1930s, sporty beach recreation was in vogue everywhere. The sunny climate of Australia's coastal urban centres ensured that bathers and surfing became images of a dynamic, modern and free nation. Harold Cazneaux exploited a fashion for dramatic camera angles by making a picture of surfers whose heads appear like corks in the breaking waves. In contrast, his younger contemporary Max Dupain produced a monumental sunbaker in 1937. His subject's triangular form combines static strength and a hedonistic abandonment on the sands. Dupain was an enthusiastic follower of modern ideas, including the psychological mysteriousness of European surrealism. Dupain's image has become a 'timeless' Australian icon but the mood is also brooding and the land as harsh as a desert.

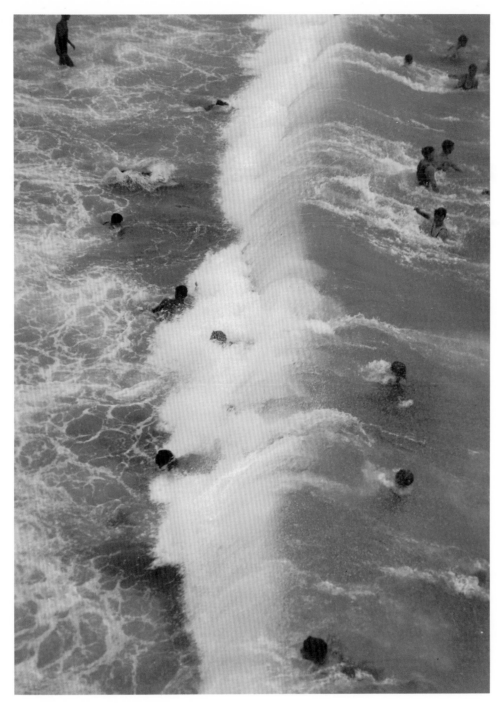

34. **Harold Cazneaux**, Sydney surfing, *c.*1928

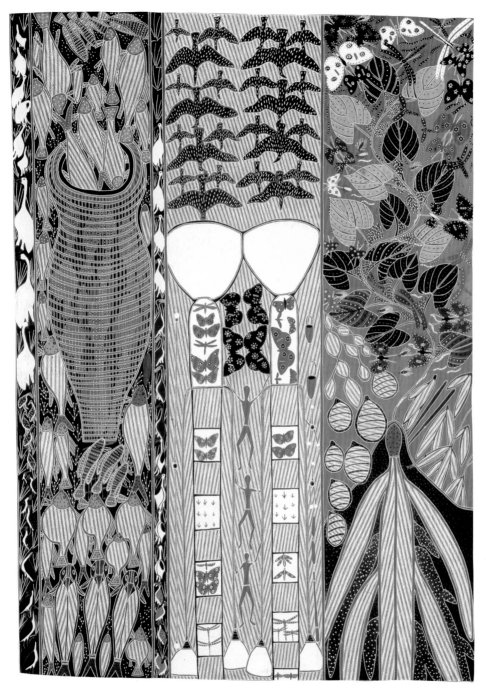

An intricate network of Dreamings covers the Australian continent. The epic journeys and deeds of the ancestral beings in the Dreaming provide Aborigines with major art themes. For the Manggalili clan of North East Arnhem Land, the ancestral sisters, called Nyapililngu, are the beings who spun possum-fur string to create the rolling sand dunes surrounding the bay at Djarrakpi, Narritjin Maymuru's country.

The Dreaming relates the genesis of the world and includes a code of living still relevant to Aboriginal people. The narratives and songs of the Dreaming are often about human and natural cycles — the passage of time and seasons, the cycle of birth, life, death and regeneration. For example, in the Dreaming the Tiwi people of Bathurst and Melville Islands were immortal until the ancestress Bima neglected her baby son Jinani. Jinani died and in his grief, Bima's husband, the great ancestor Purukuparli, decreed that death would be the fate of all Tiwi.

Jack Wunuwun's symbol for passing time is the morning star heralding a new day. He illustrates seasonal rhythms by flocks of ibis announcing the rainy season, the yam plant flowering late in the wet and rivers running with fish before the beginning of the dry season. These cycles must be prompted by people through ceremony and art. This art remains an important way for people to celebrate the continuity of life.

35. **Jack Wunuwun**, Banumbirr the Morning Star, 1987

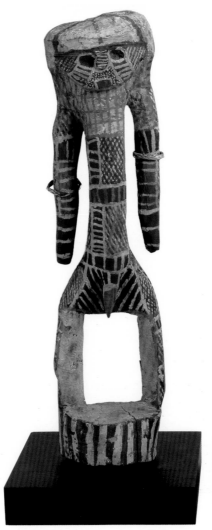

36. **Narritjin Maymuru**, Nyapililngu ancestors at Djarrakpi, *c.*1978

37. **Enraeld Djulabiyanna**, Purukuparli and Bima, *c.*1955

25

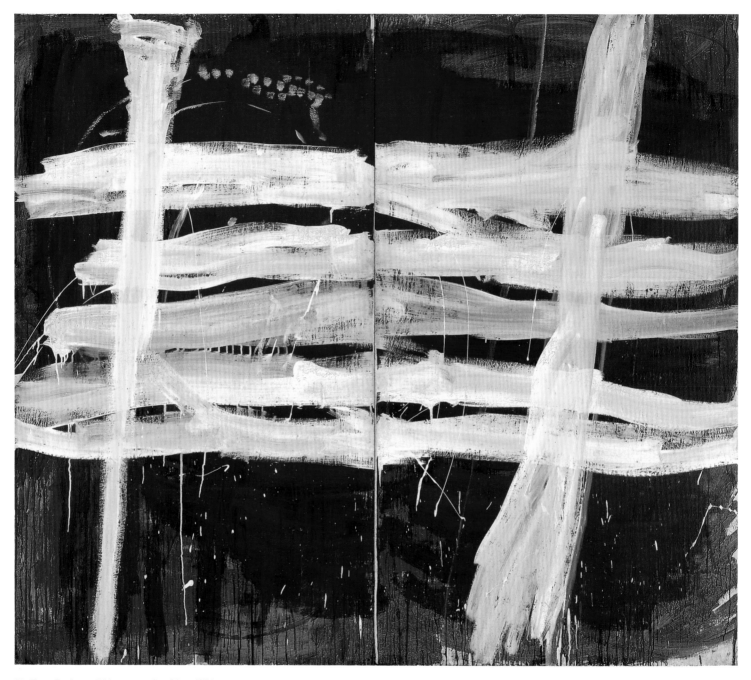

38. **Tony Tuckson**, White over red on blue, 1971

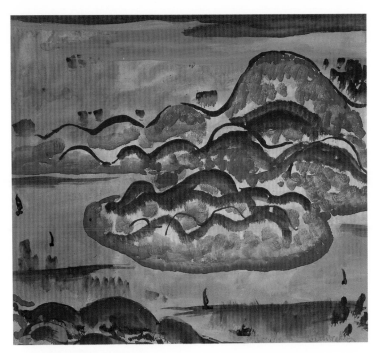

39. **Ian Fairweather**, Lake, Hangchow, 1941

40. **Rover Thomas**, Cyclone Tracy, 1991

Tony Tuckson, Ian Fairweather and Rover Thomas are painters who have sought to convey their feelings about the world rather than capture a realistic likeness. Above all, these three paintings, spanning fifty years, are celebrations of the art of painting. The artists paint from their experience of life rather than remotely from garrets, and as a result each has derived a particular freedom of expression.

Rover Thomas, a wandering stockman for most of his life, inherited his methods and symbolism from his cultural background. However, he goes beyond traditional techniques to express a highly individual response to the landscape. Ian Fairweather had the freedom of the itinerant world citizen. Often isolated from society, he was never influenced by fashions in art. Tony Tuckson accepted the self-imposed 'freedom' of the secret painter. He was able to push and explore painting because he did not intend it for public consumption. Both Tuckson and Fairweather paid homage in their western-style paintings to the delicacy and subtlety of Aboriginal style.

41. **John Olsen**, Spring in the You Beaut Country, 1961

42. **Danila Vassilieff**, Mechanical man, 1953

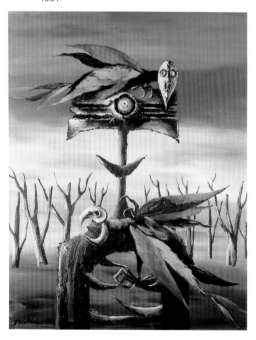

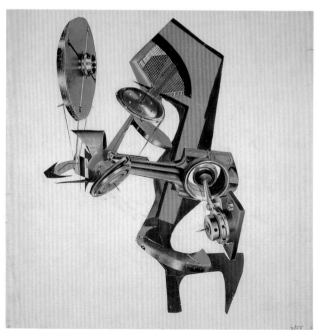

43. **Albert Tucker**, Armoured faun attacked by parrots, 1969

44. **Robert Klippel**, Untitled, 1955

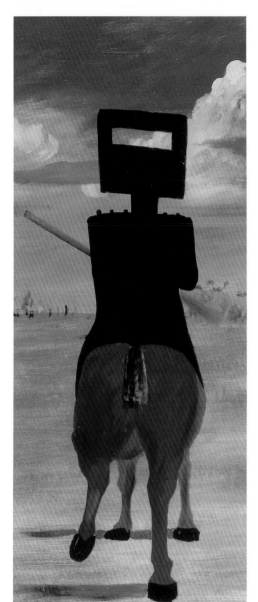

Here are intensities of emotion schematised and pared down. For John Olsen, the emotion is one of exultation in the light and energy of the land. For Albert Tucker the response to the land is heroic and resolute. Danila Vassilieff's *Mechanical man*, 1953, is as tough, sharp and dangerous as Robert Klippel's expertly balanced collage of machine parts. Reach too close and your hands will be cut. Ken Thaiday's head-dress is exuberant and serious, flashing through the air like a shark through the sunlit northern ocean.

The single focused figure is manifest in Ludwig Hirschfeld Mack's detainee in an internment camp, Sidney Nolan's *Ned Kelly*, 1946, Tucker's faun and Vassilieff's man. Each figure is individually determining his place in the world.

45. **Sidney Nolan**, Ned Kelly, 1946 (detail)

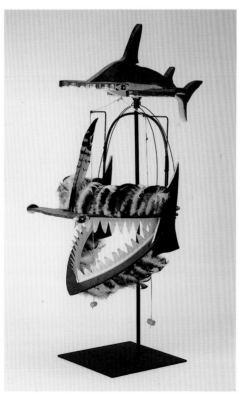

46. **Ken Thaiday**, Beizam (shark); dance mask, 1991

47. **Ludwig Hirschfeld Mack**, Desolation, internment camp, Orange NSW, 1941

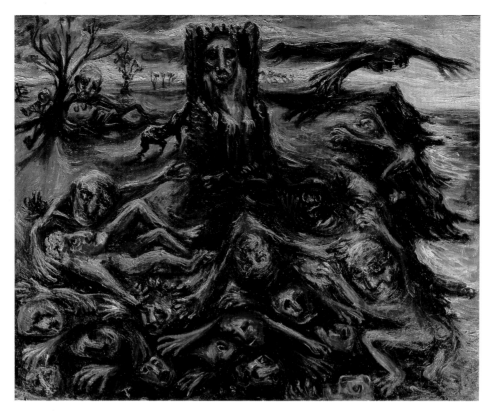

48. **Arthur Boyd**, The king, 1944

Paintings of the 1940s by Arthur Boyd, Sidney Nolan and Albert Tucker are high points of Australian art and are well represented in the national collection.

The nightmare world of the limbo between life and death, the judgement place, is the subject for Boyd's painting *The king*, 1944, and the much later untitled drawing by Sydney artist Ken Unsworth.

These images invite a passionate response. One reading is that the king, hollow-eyed and encased in his wicker-wheel-chair coffin, is surrounded by his life. His past is bathed in a golden light; his future falls crucified into the writhing mass at his feet.

In Unsworth's drawing, *Untitled*, 1987, the disembodied head floating in the River Styx is being purged of desire. 'The hot breath of dreams' erupts from his mouth. He pays a terrible price — condemned to burn alive while drowning. Burning wraiths bind the two works. In *The king*, 1944, the imminent will floats above, chronicling and judging the patriarch's life. The woman's figure rising out of the mouth of Unsworth's helpless figure is testament to past misdeeds. Both men are trapped by their fate, both are witnessed by mute attentive creatures.

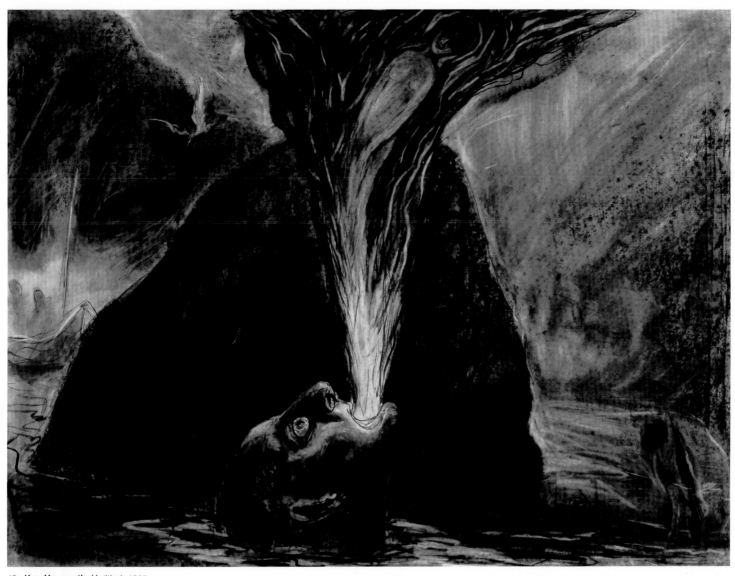

49. **Ken Unsworth**, Untitled, 1987

50. **Richard Bell**, Crisis; what to do about this half-caste thing, 1991

The Australian continent has inspired artists for fifty thousand years. From ancient rock paintings and engravings to contemporary landscapes, the land and the art of its people have never been far apart. Artists' responses to this ancient continent are as varied as human experience is diverse. Richard Bell uses the rock painting technique of stencilling to comment on Australia's recent history. Combining sympathy and wit, confidence and humour, Bell questions the value of social divisiveness. At the centre of the canvas the Rainbow Serpent eye stares back at the viewer. Above, the half black, half white harlequin figure mocks the idea of discrimination.

The land is also the subject of *Ntange Dreaming*, 1989. The artist, Emily Kame Kngwarreye, rejoices in the richness and bounty of the desert lands she has known for some eight decades. Kngwarreye's profusion of painted dots evokes the abundant 'ntange', or seeds, from which bread — the staff of life — is made. It is the land which nurtures and nourishes its people.

32

51. **Emily Kame Kngwarreye**, Ntange Dreaming, 1989

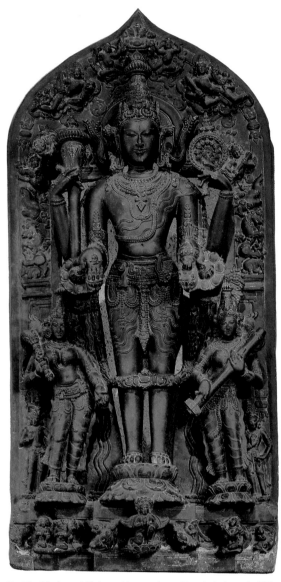
52. **The Hindu god Vishnu with attendants**, Bangladesh, early 12th century

Religion is one of the most important links uniting the art of different parts of Asia. Buddhism arose in India but there are few areas of Asia that did not eventually feel its influence. The Indian Hindu religion, while it did not seek converts, spread into Southeast Asia along with Indian traders. Islam, the latest of the great religions of Asia, first took hold in the Arab lands of the Middle East. It proved especially popular among the traders who sailed between Asia's cosmopolitan ports.

Hindu art uses images to direct the worshipper towards the godhead. It portrays gods such as Vishnu and Shiva with more than two arms. These additional hands represent divine rather than human realities. They carry various symbolic objects or make symbolic gestures.

The first human representations of the Buddha appeared in India about 500 years after his death in *c.*483 BC. Images of bodhisattvas, the compassionate beings who delay their own nirvana to help others attain this ultimate goal of Buddhism, are also extremely popular. Buddhist and Hindu art share many formal features, such as the symbolic hand gestures.

The Arabic script, in which the Koran was first recorded, is highly revered throughout the Islamic world, from North Africa to the Middle East, from India to Southeast Asia. Written from right to left, it is also the subject of one of the world's most refined calligraphic traditions.

53. **'Abdullah al-Sayrafi** (Iran, died 1342), Page of Arabic calligraphy

54. **Heirloom textile**, India, *c*.1635, traded to Indonesia

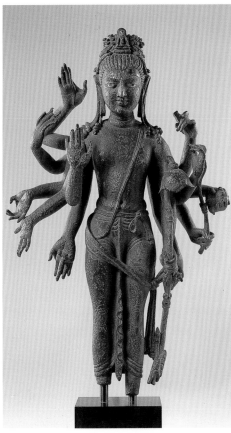

55. **The bodhisattva Avalokiteshvara**, North-west India, *c*.700

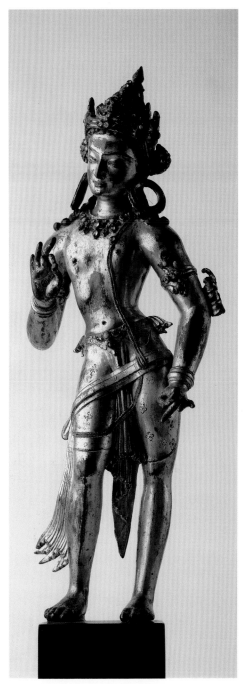

56. **The bodhisattva Avalokiteshvara**, Nepal, 13th century

The art of East Asia is linked by shared cultural traits, notably religion and language. Buddhism travelled along the great trade routes from India, over the Himalayas, to China, Korea and on to Japan. Chinese was the shared language of educated people throughout this part of Asia.

Buddhist art included representations of historical figures as well as images of deities. Prince Shōtoku (574–622) is remembered as the founding father of the Japanese state and an ideal Buddhist king. In Japan, Buddhist symbols were used widely. The eight-spoked wheel representing the noble eight-fold path of Buddhism appeared in many places, including on costumes for the Nō theatre. In China, Buddhist symbols, including the endless knot and the wheel of the law, were often combined with classical Chinese motifs such as dragons and pearls, and Daoist emblems such as the branch of coral.

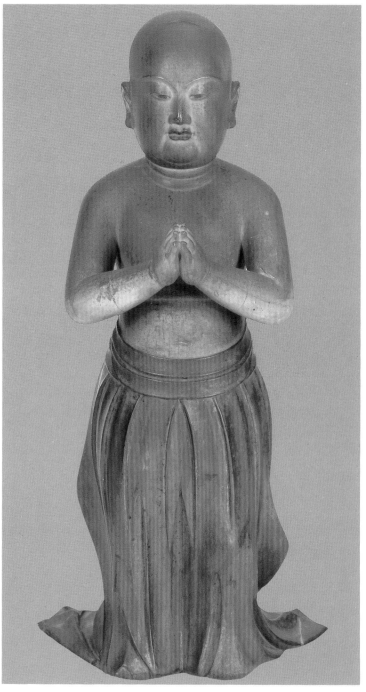

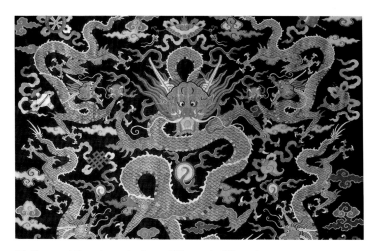

57. **Ceremonial hanging and valance**, China, early 17th century

58. **Prince Shōtoku** praying to the Buddha on his second birthday, Japan, c.1300.

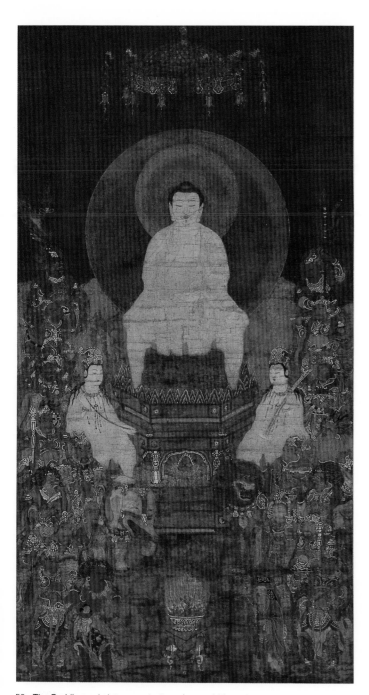

59. **The Buddha and sixteen protectors**, Japan, 14th century

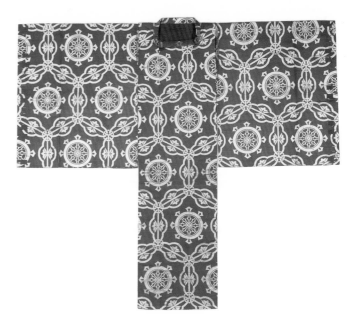

60. **Kariginu robe for Nō theatre**, Japan, late 17th century

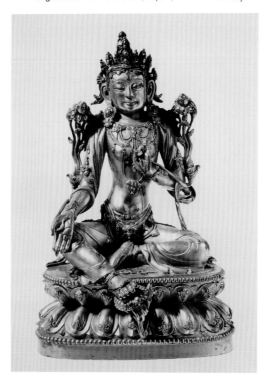

61. **The Goddess Tara**, China, *c.*1426–35.

The influence of foreign trade and religion in Southeast Asia spread unevenly. Some peoples on remote islands and isolated mountain interiors still follow ancient beliefs in ancestors and spirits. Their burial practices reflect these beliefs, with startling sculptures and grotesque faces used to scare off malevolent beings.

From about 1500 years ago the developing courts of Southeast Asia adopted Indian political and religious systems — Buddhism and Hinduism. The great monuments of Angkor in Cambodia, Pagan in Burma and Borobodur in Indonesia are reminders of the magnificent architecture and sculpture created at the height of this era. While Buddhism is still the chief religion of Thailand, Burma and Cambodia, many of the cultural centres of island Southeast Asia and the Malay peninsula are now Islamic. Their pageantry and customs display a blend of symbols — ancestral, Hindu and Islamic. The art of the region still draws inspiration from the great Indian epics, such as the *Ramayana*.

Throughout Southeast Asia, the dual and complementary aspects of male and female worlds extend throughout social and ritual life. Each male activity is balanced by a female one. Male arts of carving and metalwork are complemented by the paramount female art — magnificent decorative textiles.

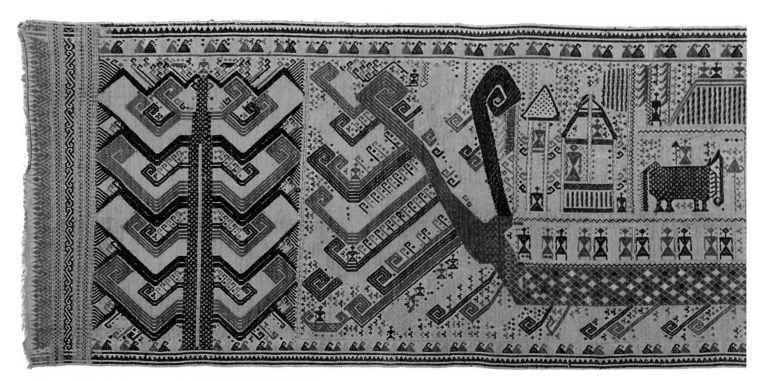

62. **Ceremonial hanging**, Lampung region, Sumatra, Indonesia, 19th century

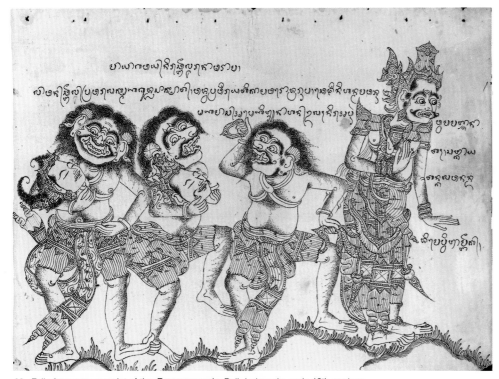

63. Folio from a manuscript of the *Ramayana* epic, Bali, Indonesia, early 19th century

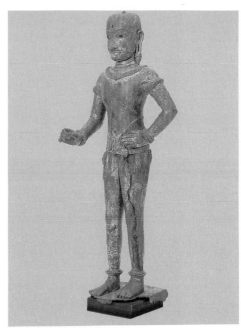

64. **Male deity**, Angkor period, Cambodia, *c.*1010 – 50

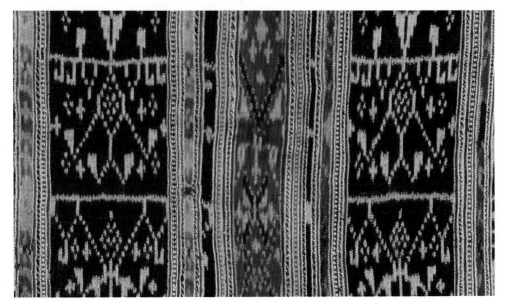

65. **Woman's ceremonial skirt**, Laos, 19th century (detail)

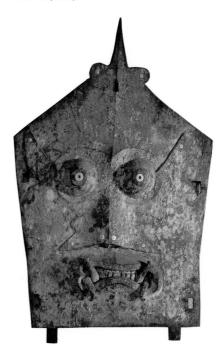

66. **End-panel of a funerary vault**, Kalimantan, Indonesia, late 19th–early 20th century

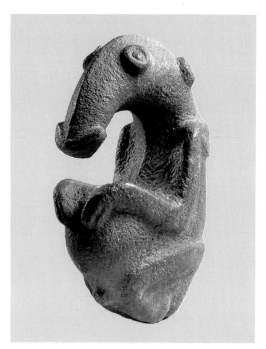

67. **The Ambum stone**, Ambum Valley, Papua New Guinea,
pre-historic period

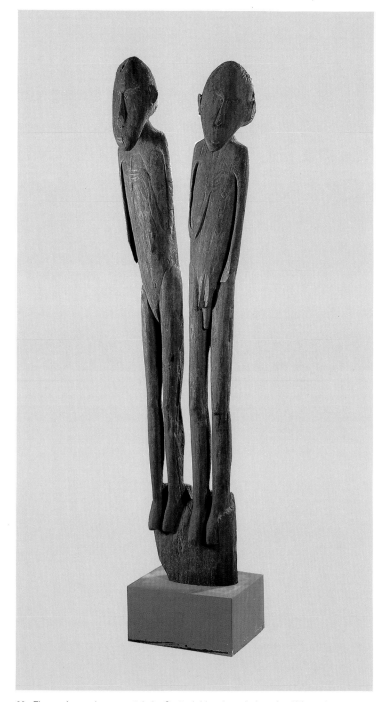

68. **Figures from a housepost**, Lake Sentani, Irian Jaya, Indonesia, 19th century

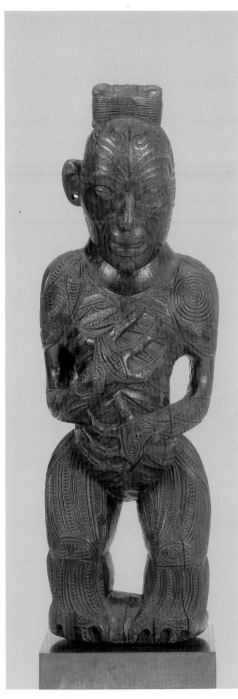

69. **Ancestor figure from a housepost**, North Island, New Zealand, c.1840

The National Collection contains select works that are outstanding in their depiction of cultures existing in Australia's region, Oceania.

Figures from a house post, 19th century, from Lake Sentani in Irian Jaya is possibly the most accomplished sculpture from New Guinea's islands. The people of Lake Sentani construct their buildings on stilts in the lake. The house posts supporting these structures are formed from upturned tree trunks which are often highly decorated. The Gallery's figures were submerged in Lake Sentani to protect them from the missionaries who brought Christianity to New Guinea at the end of the nineteenth century. The missionaries destroyed everything they thought was a pagan idol. The sculpture, which originally would have been brightly painted, was retrieved from the lake in 1929. It was saved by Jacques Viot on behalf of the famous French art dealer Pierre Leob, and later owned by the English sculptor Jacob Epstein.

While the Lake Sentani figures date from the last century, another masterpiece of New Guinea art pre-dates known art styles. The so-called Ambum stone was discovered in a cave in the Ambum Valley in the Western Highlands of Papua New Guinea in the early sixties. This rare metamorphic image with humanoid features, possibly representing the embryo of an echidna or ant-eater, may well be hundreds, if not thousands, of years old.

Another of Australia's neighbours is New Zealand. The Maori *Ancestor figure (putokomanawa) from a house post*, c.1840, as with the Sentani figures, dates from the nineteenth century. It once formed part of a post which supported a crossbeam in a Maori meeting house. The Maori work shares the refined naturalism of the Sentani figures. It may be the work of the master carver Raharuhi Rukupo.

The feelings of dignity and reverence, power and spirituality in these three figure sculptures transcend barriers of time, place and culture.

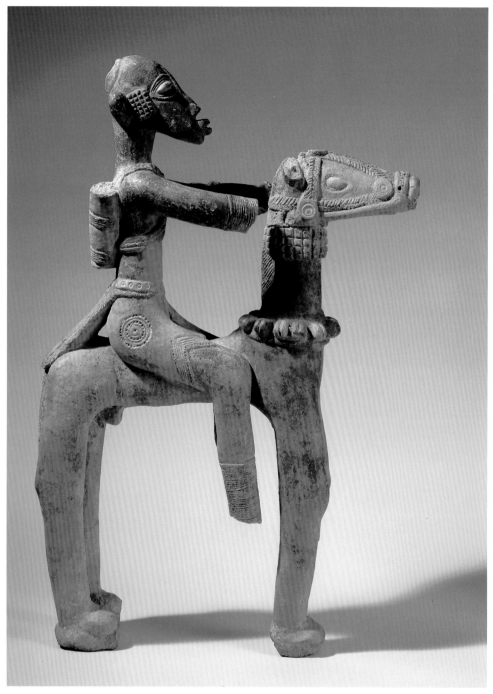

70. **Horse and rider**, Djenne, Mali, 14th century

42

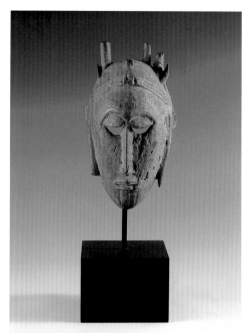

71. **Mask**, Mali, 19th century or earlier

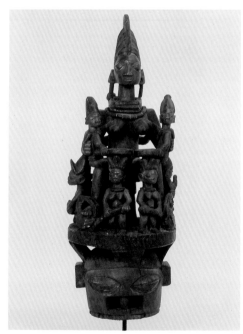

72. Attributed to **Arowogan**, Nigeria, Olomoyeye mask of the Epa festival, early 20th century

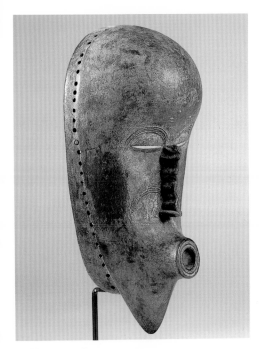

73. **Mask**, Ivory Coast, 19th century

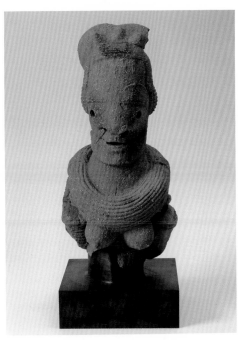

74. **Head and torso**, Nok, Nigeria, *c.*325 BC–AD 275

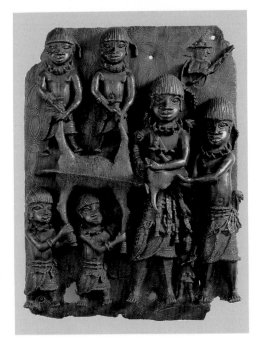

75. **Plaque representing a sacrificial scene**, Benin, Nigeria, 16th century

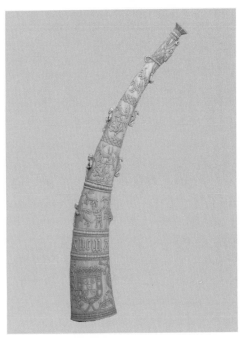

76. **Afro-Portuguese hunting horn (The Drumond Castle Oliphant)**, Sierra Leone, *c.*1500

The art of western and central Africa represents centuries of developments within a myriad of cultures and societies. The earliest African terracotta sculptures come from the ancient city of Nok in Nigeria. They date from 500 BC to AD 200. The *Head and torso*, *c.*325 BC– AD 275 is an outstanding work of this era. The ceramic sculpture of *Horse and rider*, 14th century, depicts the stately bearing of a high priest or ruler of Djenne, in what is now the country of Mali.

Not long after Djenne was at the peak of its powers, the Portuguese began discovering the riches of Africa. They commissioned artists among the Sherbro people on the Guinea coast. The ivory hunting horn now known as the *Drumond Castle Oliphant* was made in about 1500 as a gift from Manuel I of Portugal to the Spanish court.

Wood sculptures usually have a shorter life but the Bamana mask from the arid country of Mali may be several hundred years old. The more recent highly stylised Senufo mask from the Ivory Coast carries images of flowing water — the source of life — in the meandering line of the nose. Mask-making traditions continued in the twentieth century, with the Epa cult mask of the Yoruba in Nigeria depicting a mother surrounded by children or small figures.

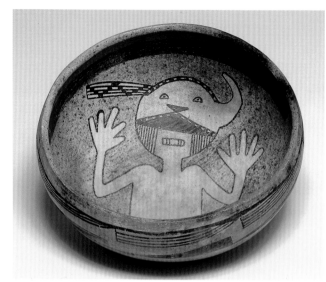

77. **Bowl with human figure**, Hopi culture, United States of America, *c.*1400–1650

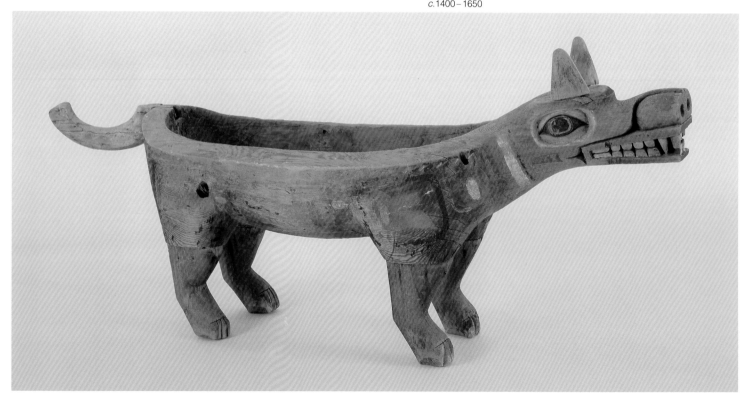

78. **Feast dish**, Kwakiutl people, Canada, early 20th century

The ancient cultures of the Olmec and Maya in central America believed they were descended from the union of a jaguar and a woman. Their divine rulers, direct descendants of this marriage, built large cities with pyramids and temples. They amassed enormous wealth and were given ostentatious burials. The jade mask probably represents one such ruler. Its naturalism indicates the human aspect, the curve of the upper lip hinting at the features of the divine jaguar.

The Maya, renowned for their wealth of artworks, continued many Olmec traditions. Their finely painted ceramics stand out. The glyphs on this painted vase indicate it was made during the eighth century AD. It depicts a ceremony at which attendants wait upon a ruler on his throne. The gourds or jars are thought to contain a potion used in ritual enemas. Tairona culture of present-day Colombia made much of its fabled gold, which attracted Iberian explorers 500 years ago. The splendid appearance of the rulers of the ancient worlds is evident in the figure of a warrior or god wearing a head-dress of feathers and birds' heads.

In about AD 1500, when the Tairona were coming to the end of their power, the Hopi people of the pueblo of Sikyatki in Arizona had developed sophisticated ways of working with ceramics. The *Bowl with human figure*, *c.*1400–1650, is exceptional in that human figures rarely appear on such pottery. This boldly painted image probably represents a ceremonial dancer, later known as Kachina.

Among the most spectacular North American art works in the National Collection is a Kwakiutl feast dish, shaped in the form of a wolf. Such dishes are used in the potlach, an extravagant exchange ceremony of the north-western coast Indians. This dish was once owned by the Surrealist artist Max Ernst.

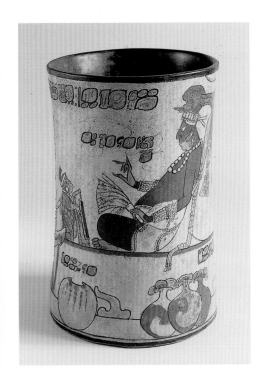

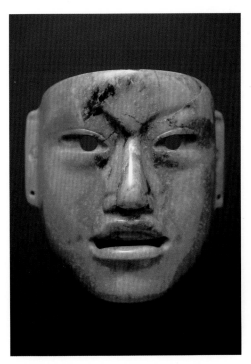

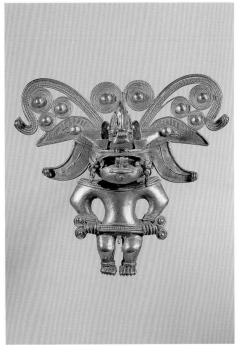

79. **Vase**, Maya culture, Guatemala, 8th century

80. **Mask**, Olmec culture, Mexico, *c.*1200–800 BC

81. **Pendant in the form of a warrior or god**, Tairona culture, Colombia, *c.*1000–1500

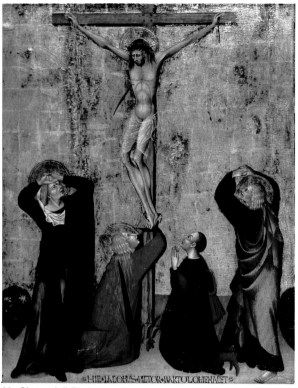

82. **Giovanni di Paolo**, Crucifixion with donor Jacopo di Bartolomeo, *c.*1444

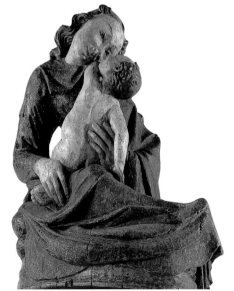

83. Madonna of Humility, Ferarra, Italy, *c.*1470

The National Gallery's collection is essentially modern. Its international collections parallel the recorded developments in Australian art over the past 200 years, and find their strength in the twentieth century. The representation of European art before 1800, although small, contains a number of outstanding works of international significance.

The *Crucifixion* of Giovanni di Paolo is a magnificently preserved example of fifteenth-century Italian art. The artist painted in tempera, a water-based paint, on poplar wood panel, the work bounded by a facing of gold leaf. He followed the conventions of the day in the placement of figures and the colours of clothes to make his work legible to a broad audience. The church, the prominent patron of artists in Italy at the time, regularly commissioned works for instructional and devotional display to the public. This painting was a private commission, and commemorates the death of Jacopo di Bartolomeo, with the donor shown kneeling at the foot of the cross with the grieving saints. The Latin inscription at the bottom reads 'Here lies the painter Jacopo di Bartolomeo'.

The carved *Madonna of Humility, c.*1470, from Ferarra still obeys the conventions that allow the public to read the work, but a new spirit of naturalism is apparent in the appealing gesture of the child's caress.

The *Self-portrait,* 1623, by Peter Paul Rubens is a triumph of naturalism. The development of oil paint in Northern Europe in the fifteenth century gave artists greater control over colour and tone, allowing for a rich, realistic depiction of the world. Rubens was a master of paint handling — apparent in both the paintwork and in his depiction of himself as a successful man of the world. In the seventeenth century, when this portrait was painted, an artist could count on sales to royalty, the aristocracy, wealthy merchants and the church. Rubens mixed with all of these groups as an equal. It was inconceivable that he would paint himself with the unadorned humility that characterises Giovanni di Paolo's portrait of the artist Jacopo di Bartolomeo.

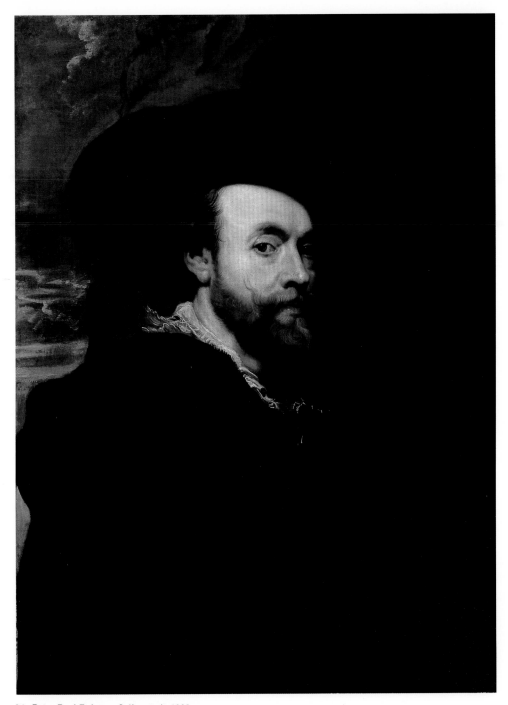

84. **Peter Paul Rubens**, Self-portrait, 1623

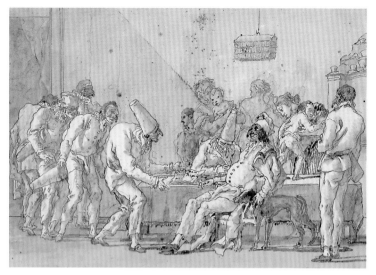

85. **Giovanni Domenico Tiepolo,** Collecting the rent, c.1800

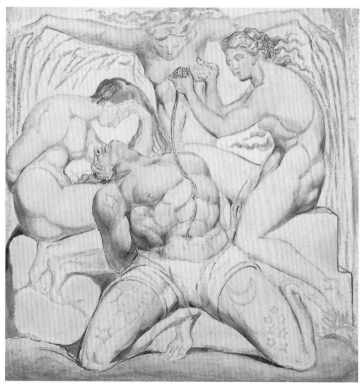

86. **William Blake,** Jerusalem, Plate 25, 1804–20

The end of the eighteenth century was a turning point in our civilisation — great changes were underway, but their effect had not been realised. There is little in these images to suggest the impact of the French Revolution or the technological changes of the industrial revolution that began in Great Britain.

This is to be expected in *The marriage allegory of the Cornaro family, c.*1750, by Giambattista Tiepolo. The painting uses arcane references to myths and symbols to tell of a perfect marriage — the dog represents faithfulness, its leash tied to Cupid's quiver of arrows which represent love. Originally set into a ceiling in an Italian palazzo and viewed from below, Tiepolo intended to trick the eye into seeing the painting as part of the ornate architecture.

Giambattista's son, Giovanni Domenico Tiepolo, also reflects the social order of the past with the masked clowns in his drawing *Collecting the rent, c.*1800. Giovanni seems to have chosen the subject — the life and adventures of a figure from Italy's *commedia dell'arte,* Punchinello — for its comic possibilities rather than social comment.

The images by Blake and West mark the beginnings of modern experience. William Blake, poet, artist and eccentric, was a man of his time, sensitive to the changes about him and inspired by the democratic ideals of the French Revolution. His hand-coloured relief print was one of a series illustrating Jerusalem, his poetic text prophesying a spiritual Utopia.

Benjamin West's *Angel of the Resurrection,* 1801, is the earliest work by an artist using the new printing method of lithography which was invented by Aloys Senefelder a few years before. As such, it announces a commitment to a new age.

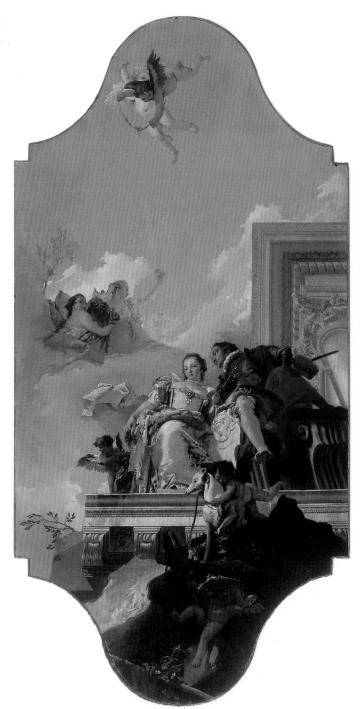

87. **Giambattista Tiepolo**, The marriage allegory of the Cornaro family, *c.*1750

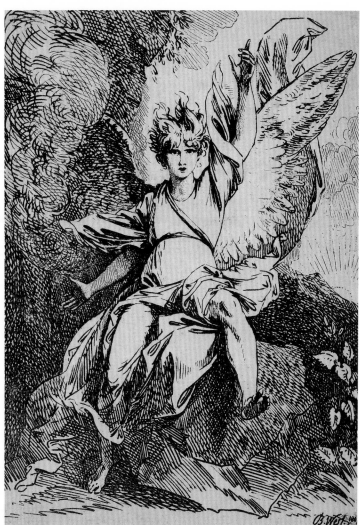

88. **Benjamin West**, Angel of the Resurrection, 1801

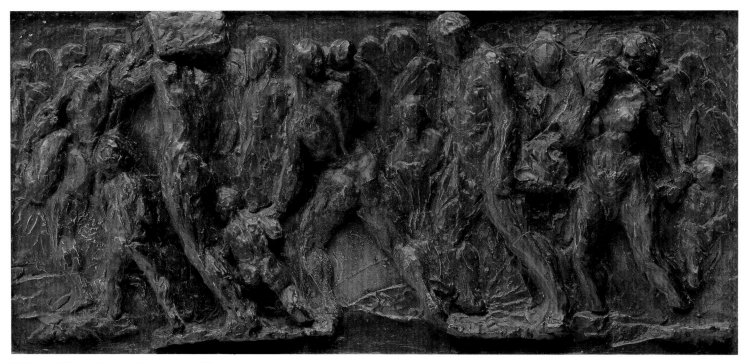

89. **Honoré Victorin Daumier**, Emigrants, c.1850

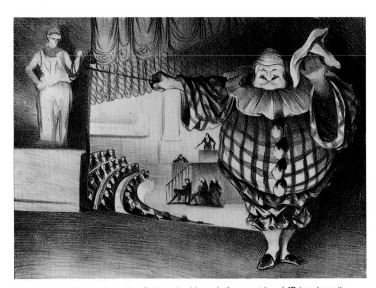

90. **Honoré Victorin Daumier**, Baissez le rideau, la farce est joueé [Bring down the curtain, the farce has been played out], 1834

Courbet's nineteenth-century audience was not ready for his frank and earthy paintings. Parisians were shocked by this study for one of Courbet's most famous paintings. Two women lounge on the bank of the river Seine, a seemingly innocent subject and one popularised by the Impressionists a decade later. However, the women were almost undressed and perhaps were even prostitutes. Just as vulgar and unforgivable was Courbet's direct and visible handling of paint, which he often applied with a palette knife.

Honoré Victorin Daumier was jailed for his forthright opinions of French society. His political cartoons mercilessly criticised Louis-Philippe, the constitutional monarch of France. Here he lampooned the hypocrisy of the autocrat who pretended to consult with Parliament. Louis-Philippe, dressed as a clown on the stage, tips the scales of Justice as he brings down the curtain on the farce of consultation. His plaster relief, *Emigrants*, c.1850, is both a metaphor for the political opponents of the monarchy driven into exile after the failure of the 1848 revolution and also an image of the toiling anonymous masses.

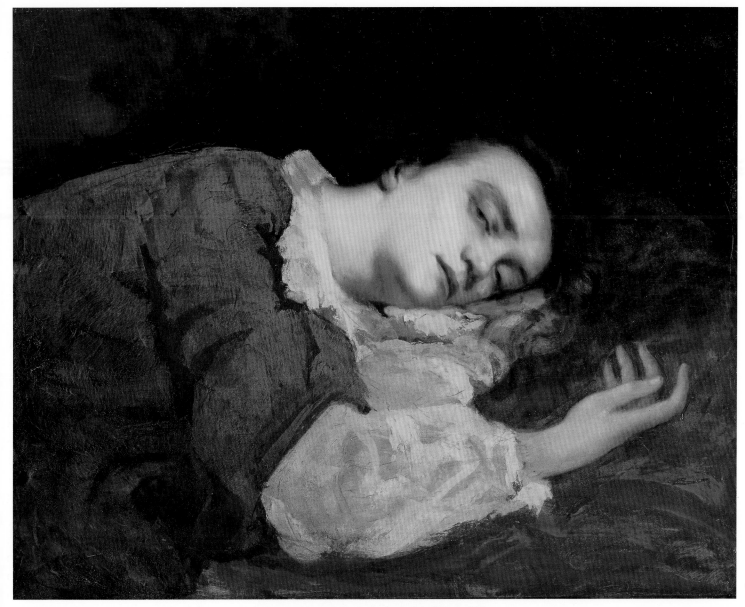

91. **Gustave Courbet**, Study for Les demoiselles au bord de la Seine [Young ladies on the bank of the Seine], 1856

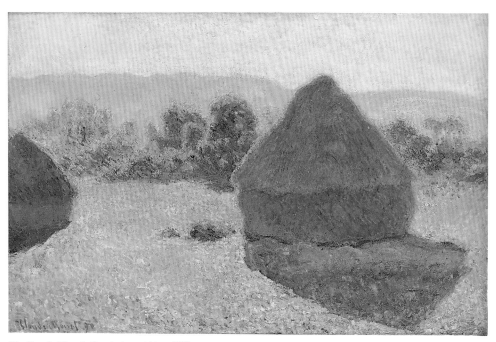
92. **Claude Monet**, Haystacks, midday, 1890

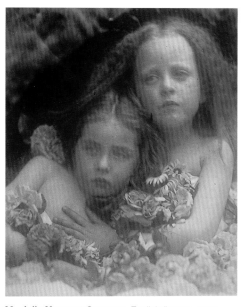
93. **Julia Margaret Cameron**, English flowers, 1873

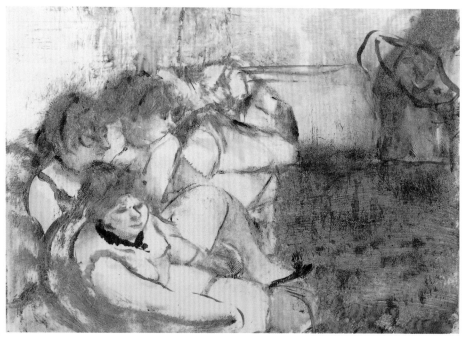
94. **Edgar Degas**, Au salon [At the salon], 1879–80

From the late summer of 1890 through to the winter of 1891, Monet worked on at least twenty-five paintings of these haystacks. Their simple composition allowing him to concentrate on his real subject — light. He was fascinated by the way in which the haystacks were transformed by the changing quality of light at different times of day and in different seasons. With their focus on the fleeting effects in nature, observed and painted outdoors, these paintings represent a climax of Impressionism.

In the last twenty years of his life, Monet painted the large waterlily pond in his garden at Giverny, a small village near Paris. There, in the surface of his pond, Monet discovered a perfect playground for the most subtle, ever-changing effects of light.

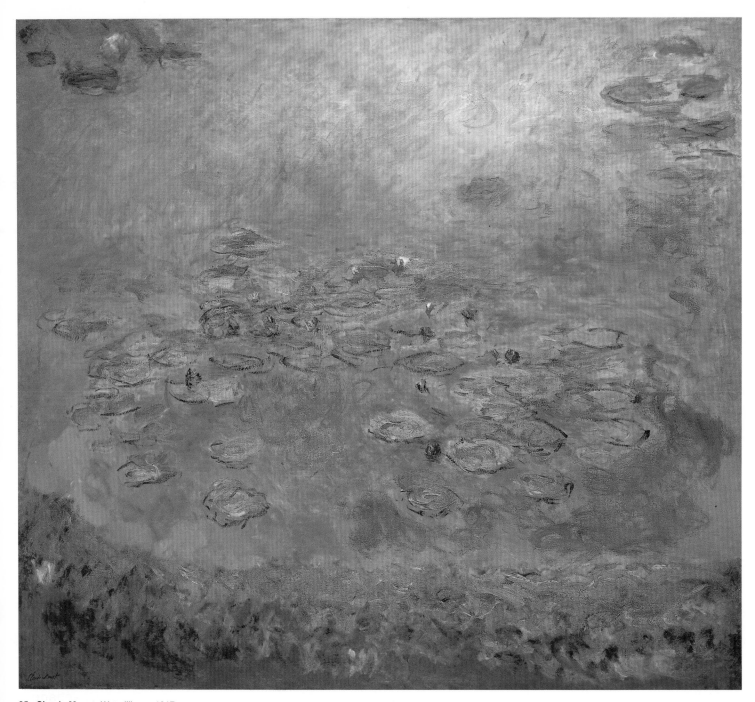

95. **Claude Monet**, Waterlilies, *c.*1917

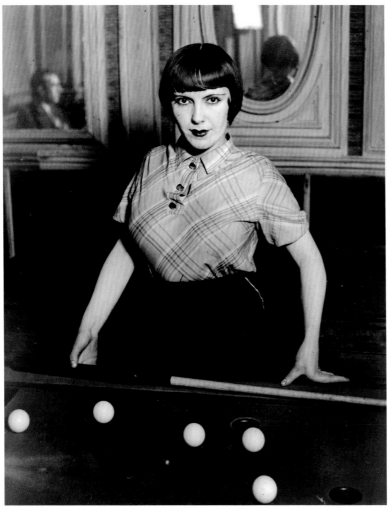

96. **Brassaï,** A prostitute playing Russian billiards, Boulevard Rochechouart, Montmartre, c.1932, printed 1973

When the Impressionists painted the streets and suburbs of Paris and the work and leisure times of its inhabitants they portrayed an optimistic and respectable middle class. The less respectable and less reputable life on the streets was left to others to document. Henri de Toulouse-Lautrec and the photographer Brassaï were both punctilious in touring Paris nightspots and dutifully recording all that they saw.

The portrait of the female clown Cha-U-Kao is from a suite of prints titled *Elles (Womankind)*, 1896, that focuses on the denizens of the after-dark world. Lautrec based *Elles* on a set of colour woodcuts depicting the lives of prostitutes by the eighteenth-century Japanese artist Utamaro. All the prints show scenes from a brothel in rue des Moulins. The exception is this colour lithograph of the demi-mode entertainer Cha-U-Kao. Garishly attired and made-up, she sits apart from the seedy revelry of the Parisian music hall.

From the moment of his arrival in Paris in 1924, Brassaï explored and photographed the street life between Montparnasse and Montmartre. His images, like those of Lautrec's, continue to form the basis of many popular romantic ideas about Paris. The immediacy of Brassaï's photographs convey the energy of Paris during that period — artists at the Café de Flore, couples embracing in bars at the Place d'Italie and chorus girls backstage at the Folies-Bergère.

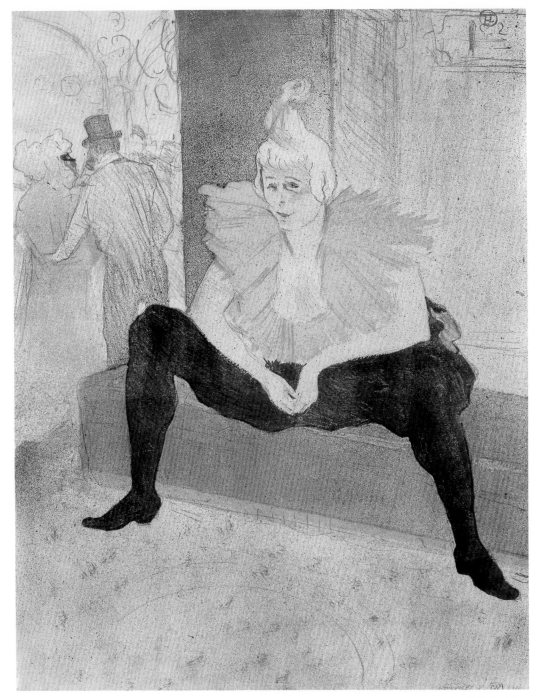

97. **Henri de Toulouse-Lautrec**, La clownesse assise: Mademoiselle Cha-U-Kao [The seated clown: Miss Cha-U-Kao], 1896

Abstract art evolved early this century in response to the idea that painting and sculpture were essentially visual languages of colour, line and form, appealing directly to the senses in the same way as music. Malevich pioneered abstract art in the years around the Russian Revolution of 1917, creating a new kind of art for a new kind of society.

Both in its title, *House under construction*, 1915, and in its style, Malevich's painting celebrates an optimistic belief in a new age. Simple blocks of colour spring to life in a dynamic composition that climbs ever upward, symbolic of a society building itself from scratch.

Delaunay, like her contemporaries, wanted to convey the excitement of modern life. *La prose du Transsibérien*, 1913, is a book that makes a radical departure from the expected format. The artist has stencilled bold abstract forms down one side of the scroll-like book. They parallel the unfolding verse by poet Blaise Cendrars, which itself is printed in different colours and typefaces. Delaunay's bright shapes are intended as visual equivalents to the poem's description of a train journey across Russia, finally ending at a red Eiffel Tower, the symbol of modernity.

Russia was Delaunay's homeland before she moved to Paris. Illustrated book design was important in the radical art of Russia and the Gallery owns a rich collection of Russian avant-garde book illustrations.

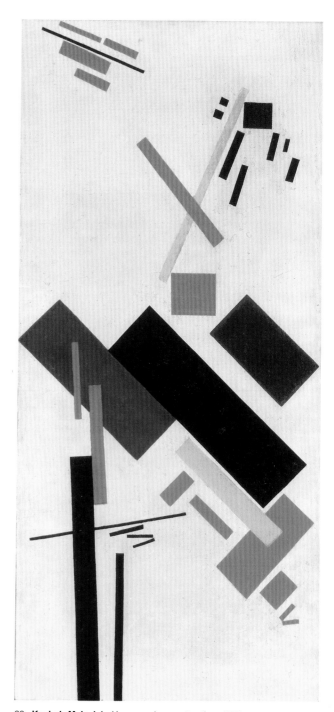

98. **Kasimir Malevich**, Suprematist cup and saucer, *c.*1925

99. **Kasimir Malevich,** House under construction, 1915

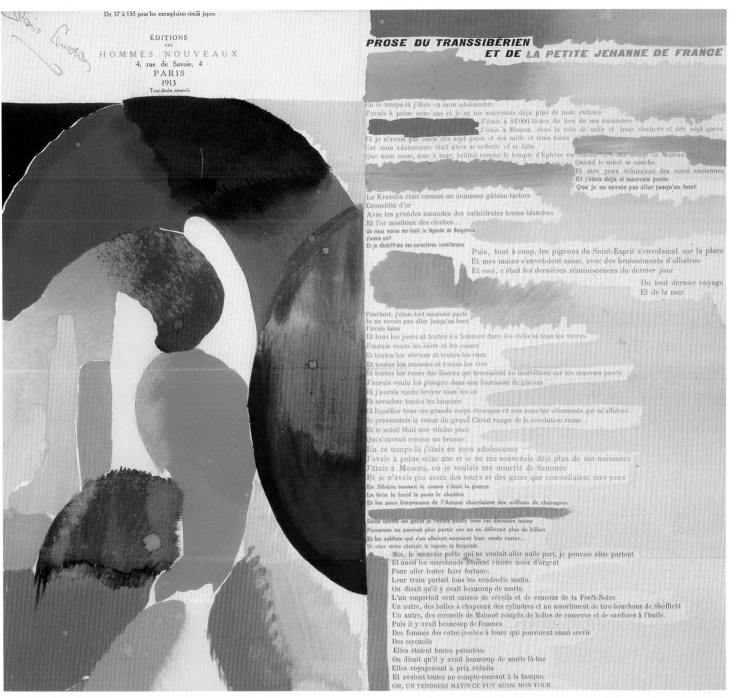

100. **Sonia Delaunay**, La prose du Transsibérien, et de la petite Jehanne de France [Prose of the trans-Siberian, and of little Jehanne of France] by Blaise Cendrars, 1913 (detail)

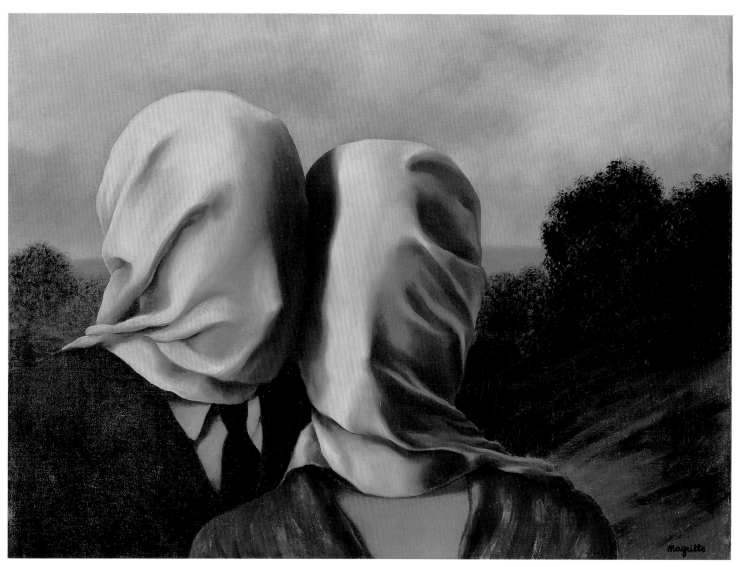

101. **René Magritte**, The lovers, 1928

Instead of celebrating logic and rationalism, Surrealists like Miró pursued the magic of the dreaming mind. Miró said: 'In a picture it should be possible to discover new things every time you see it. Whether you see in it flowers, people, horses, it matters little, so long as it reveals a world, something alive'.

That our dreams may reveal truths has become a common idea since the publication of Sigmund Freud's theories earlier this century. The Surrealists, a group of artists who first came together in Paris in the 1920s, made dreams a subject of their art. At first glance, Magritte's painting of lovers is slightly humorous. In the mind's eye, however, it becomes curiously disturbing — sensations of suffocation, even death, surface like remembered dreams or nightmares.

102. **Joan Miró**, Landscape, 1927

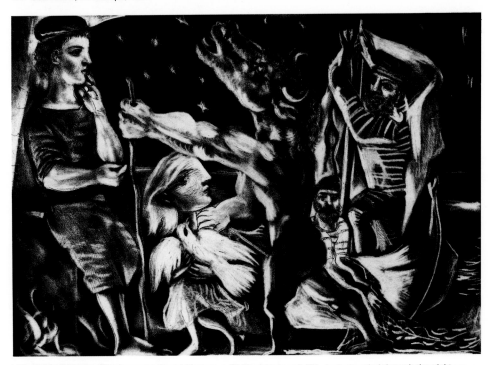

103. **Pablo Picasso**, Minotaur aveugle guidé par une fillette dans la nuit [Blind minotaur led through the night by a little girl], 1934

59

These two sculptures are examples of sculptors' attempts to elevate mass to simulate weightlessness. Each artist used a different method to achieve this effect.

Romanian artist Constantin Brancusi used carving, one of the oldest methods of sculpture-making, to describe flight in his *Birds in space*, 1931–36. American David Smith used twentieth-century methods of art-making based on technological developments to construct his *25 Planes*, 1958.

Brancusi's two *Birds in space*, 1931–36, are the climax of an extended series of sculptures. The first in the series were naturalistic birds made in 1910. The birds became increasingly abstract as the artist refined the essence of airy movement in each successive work. Canberra's two birds are the largest marbles Brancusi ever carved. They present a precarious balance between the soaring dynamics of the forms and the obdurate demands of gravity. Originally the two birds were commissioned by the Maharaja of Indore to be placed in a temple next to his palace.

Smith's *25 Planes*, 1958, are cut from stainless steel, chosen for its strength and reflective qualities. The material enabled Smith to erect a tall, almost transparent structure that played off natural connotations such as a figure or tree against the effortless floating of abstract shapes in the air.

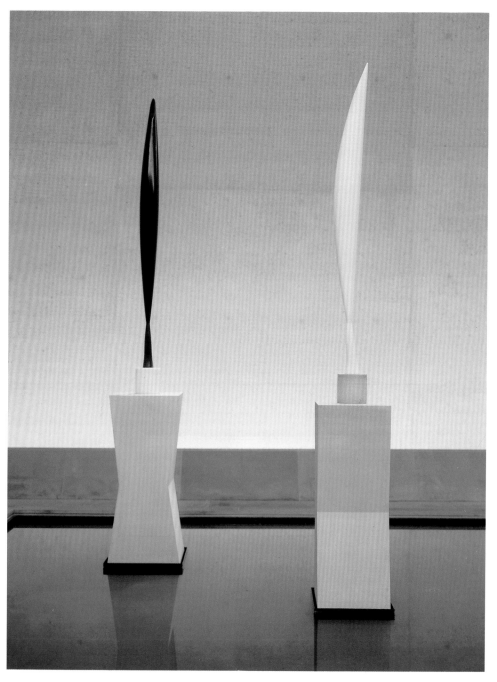

104. **Constantin Brancusi**, Birds in space, 1931–36

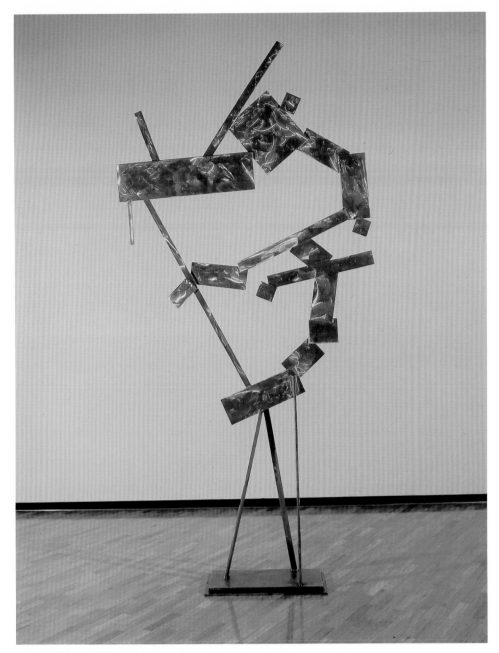

105. **David Smith**, 25 Planes, 1958

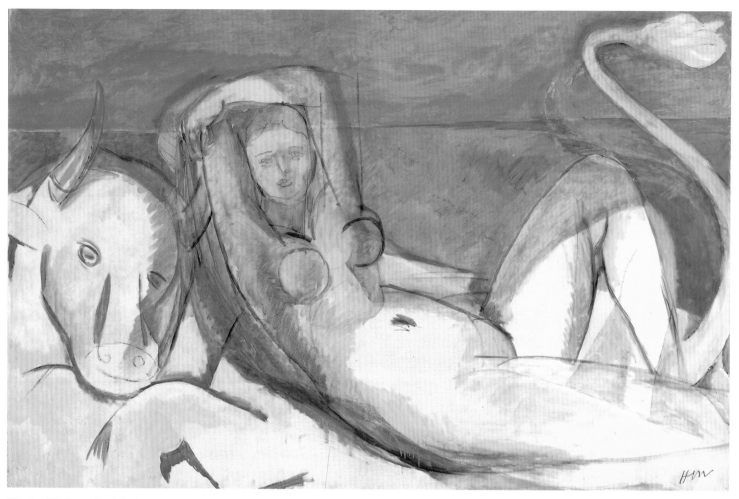

106. **Henri Matisse**, The abduction of Europa, 1929

The figure of Europa draws upon the theme of the reclining nude that preoccupied Matisse in his sculptures and prints of the 1920s. It is a work of great rarity and distinctiveness. In the Greek myth, the maiden Europa is abducted by Zeus, who has transformed himself into a bull. Matisse shows a nude Europa lying on the bull's back. But the myth is just a starting point. The artist's real interest is drawing, and Matisse does not disguise the changes he has made, preferring instead to reveal the process of making a picture.

In contrast to the austerity of Matisse's *The abduction of Europa*, 1929, the flesh of Outerbridge's *Nude lying in a loveseat*, c.1936, is palpable. Pale skin, red velvet and intricately carved wood are described with obsessive detail. The production of carbro-colour photographs is a precise and difficult process. However, Outerbridge recognised its capacity to represent surfaces and colours with great fidelity. He perfected the technique to produce scenes of fetishism and sensual decadence.

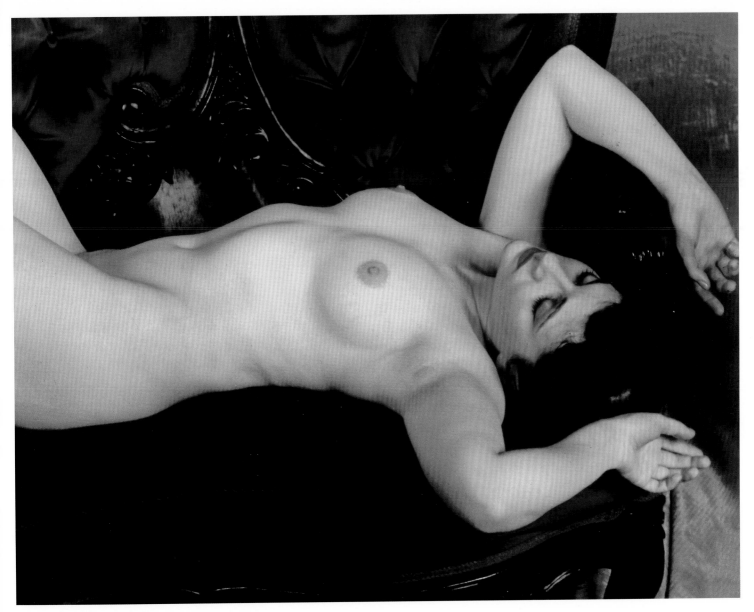

107. **Paul Outerbridge**, Nude lying on a love-seat, c.1936

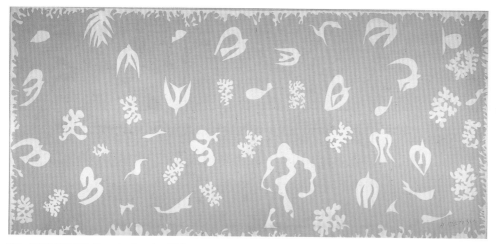

108. **Henri Matisse**, Oceania, the sky, 1946

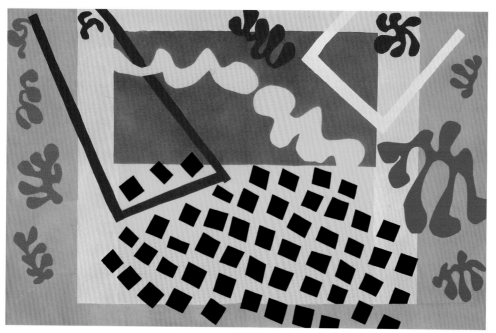

109. **Henri Matisse**, The Codomas, from *Jazz* 1947

Neither Fernand Léger nor Henri Matisse abandoned figurative art for total abstraction, though both artists shared the belief that line, shape and colour have in themselves expressive powers. Both painters reproduced only part of what the eye saw, using the line, shape and colour to convey moods and suggest feelings.

Léger suggests the excitement of the circus with expansive areas of gaudy colours overlaid by a dynamic grid. A pair of curved lines mark out the circus ring. A ladder and safety net suggest the acrobats' height and their movement through space. Léger wanted his work to be easily 'read' and understood by ordinary people. He used it to celebrate everyday life.

Oceania, the sky, 1946, recalls Henri Matisse's visit to the South Seas in 1930. Made after his trip, the image is a generalisation coloured by memory and nostalgia. In his last years, Matisse was ill and sought a less strenuous means of making art. With a pair of scissors he created coloured cut-out shapes that served as the basis of the stencils illustrating his book *Jazz*, published in 1947, and the screen print *Oceania, the sky*.

64

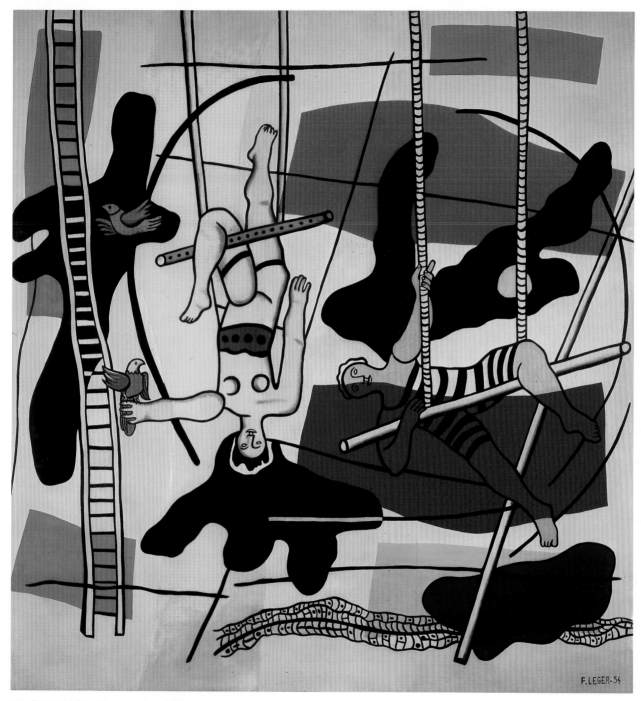

110. **Fernand Léger**, Trapeze artists, 1954

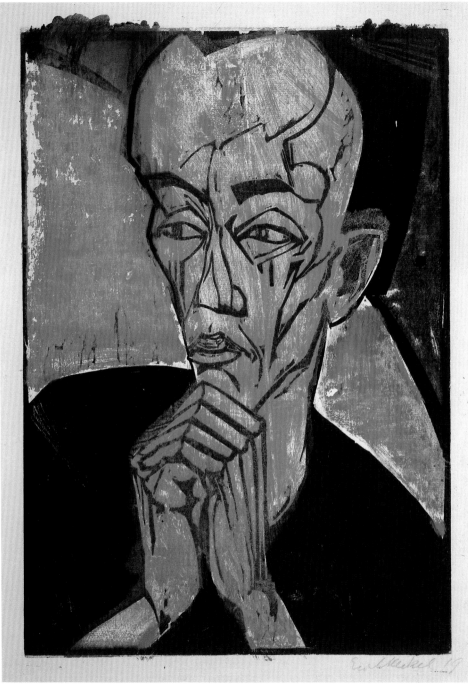

Heckel's self-portrait was conceived at about the time of the First World War. It was one of the first portraits to document a profound sense of angst and pessimism about the modern world. This dramatic colour woodcut sounds a shrill opening note to the century's mood of introspection and disillusionment. Heckel never lost his faith in art — even this stern visage has been lovingly coloured-in to maximise its impact.

Arbus took photographs that are confrontationist and controversial. She had the capacity to reveal the tragedy and absurdity in people's lives. Her photographs were not taken surreptitiously, as the subjects of her pictures were accomplices in the process. She described her camera as a 'licence' into people's lives. A noticeable sense of anguish and despair pervades many of Arbus's photographs of the sixties, emblematic of the Cold War experience in the United States.

111. **Erich Heckel**, Männerbildnis (Selbstbildnis) [Portrait of a man (Self-portrait)], 1919

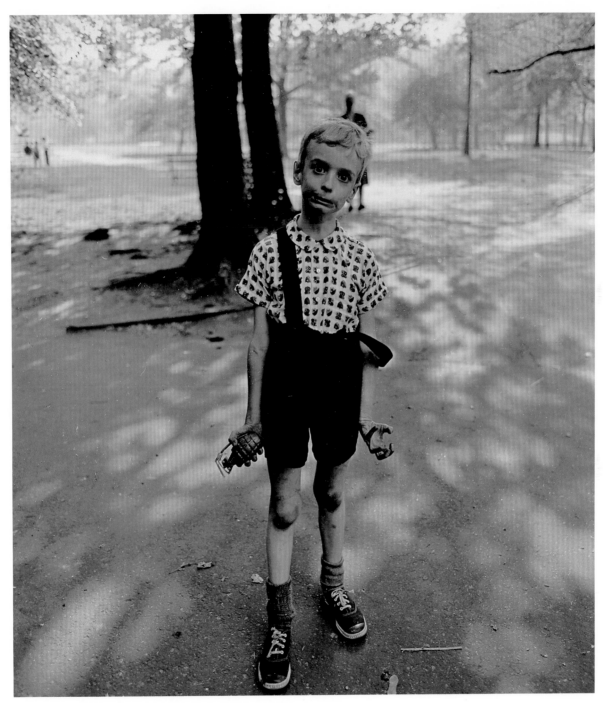

112. **Diane Arbus**, Boy with a toy grenade in Central Park, New York City, 1962

Spontaneity is important in modern art as a way of discarding the inhibitions of tradition for a direct, truthful approach. It can be traced back to the Impressionist artists, who worked outdoors, quickly and deftly. It reached a climax in Pollock's so-called 'drip paintings', of which *Blue poles*, 1952, is an example.

It is clear from the delicate, complex paint layers that Pollock did not finish *Blue poles* in a single session. The work is carefully structured. He avoids focal points that deliberately slow down and arrest attention in more conventional painting. Instead, the eye roams back and forth over the picture.

Abstract Expressionist artists valued spontaneity rather than the smooth, deliberate finish of the classical tradition. In *Woman V*, 1952–53, de Kooning used the brushstrokes, impasto and scraping of the brush to magnify the textures of skin and hair. 'Flesh was the reason why oil painting was invented', he said.

Many people believe that colours correspond to feelings. In his paintings Rothko sought to speak to the emotions through colour alone. He created penumbral clouds of colour through successive washes of thinned pigment soaked into the canvas. Rothko did not want his paintings to be framed, but desired the viewer to 'enter into the painting', and become enveloped by its colour.

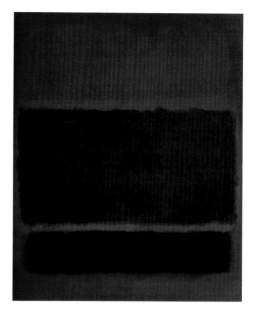

113. **Mark Rothko**, Brown, black on maroon, 1957

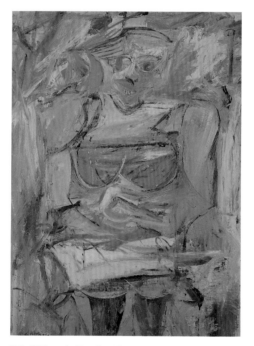

114. **Willem de Kooning**, Woman V, 1952–53

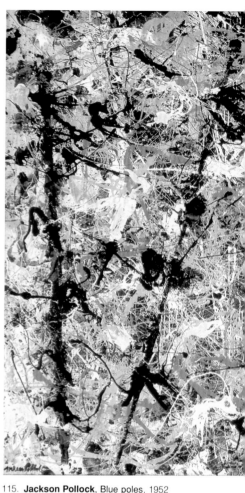

115. **Jackson Pollock**, Blue poles, 1952

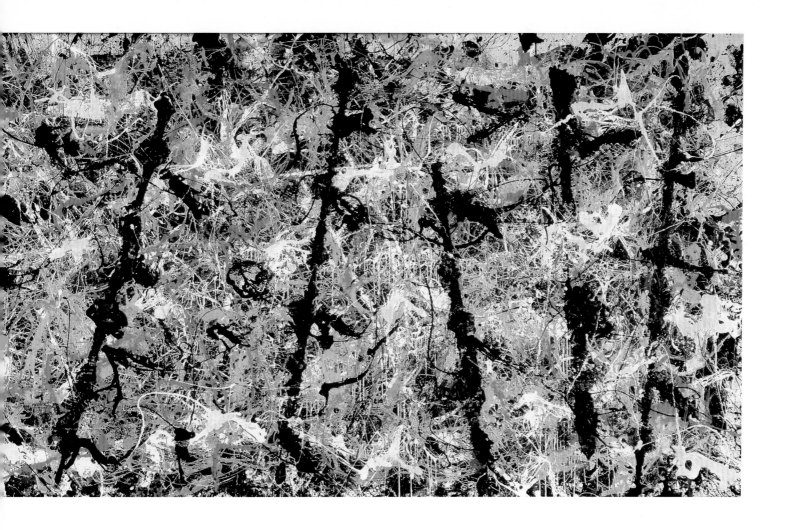

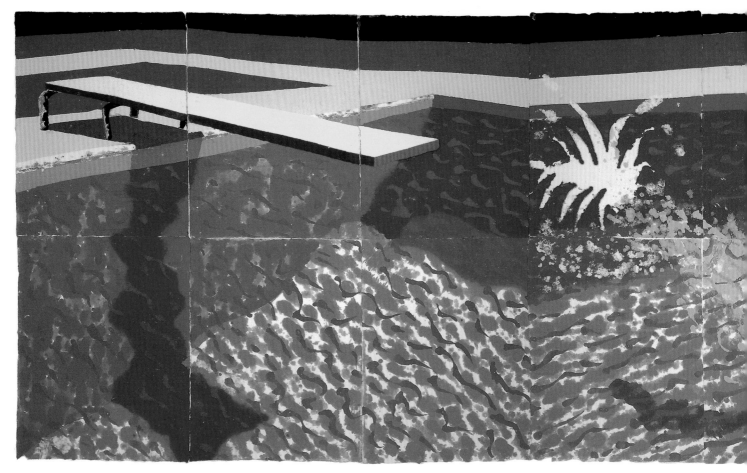

116. **David Hockney**, **A diver** (17), from the *Paper Pools* series, 1978

Since the sixties, David Hockney has explored the problem of depicting water in painting, drawing and print-making. In 1978, after seeing some recent works by artists using paper pulp, he became enthusiastic about making his own. Hockney soon realised the potential of paper pulp and once again turned to the subject of water, using this technique to his advantage. Just as Claude Monet researched the effects of differing times and seasonal variations in his many paintings of waterlilies on his lily pond, Hockney investigated the effect of light and climate on a shifting, watery surface in his series of *Paper pools*, 1978.

Unlike the heroic themes commonly found in art, the subject of Roy Lichtenstein's painting is humdrum, even banal. The image of the stove is taken from an advertisement, complete with the dots used in commercial printing for tonal areas, and the copyright symbol. Lichtenstein admired the bold compositions and economy of means of advertising art, and used them to make an ordinary object of consumer culture into an icon.

In 1973 the Gallery purchased all right-to-print proofs from the printer, Ken Tyler, when he moved from the West Coast to

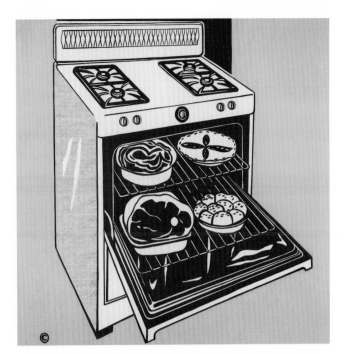

117. **Roy Lichtenstein**, Kitchen stove, 1961–62

118. **Jasper Johns**, Gray alphabets, 1968

the East Coast of America. Several artists invited to work with Tyler, such as Jasper Johns, were associated with the American Pop Art Movement, which took subject matter from popular culture. Johns refined the notion. He chose motifs for his art like alphabets or numerals, which 'the mind already knows' and reworked them in subtle configurations, such as *Gray alphabets*, 1968.

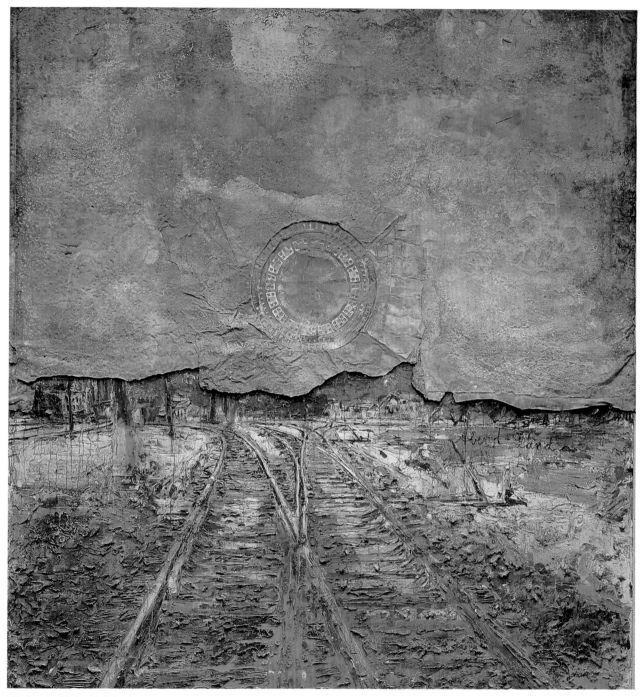

119. **Anselm Kiefer**, Twilight of the West, 1989

Figurative art regained importance with the Italian and German avant-garde in the mid-1970s. Tagged 'neo-expressionists' they used politically 'hot' subjects, national myths and personal heroics combined with emotion-charged colours and forms.

Three enormous etchings by Italian artist Mimmo Paladino form a triptych exuding mystery and sacrifice. The rich, complex embroidery of figures and symbols is a skilful interweaving of deep-rooted pagan ceremony and Christian ritual.

Anselm Kiefer divides *Twilight of the West*, 1989, into a sculptured sky and a painted earth. Lead is soft and heavy, used as a shield against radiation. Here it is stained, wrinkled and stamped with a circular man-hole cover like the sun. Lead is also the base metal which alchemists tried to turn into gold — a symbol of eternal hope and disappointment. Below, the heavily worked paint, mixed with ash and plaster slurry, shows railway tracks diverging through an industrial wasteland. There is no clear destination. 'Abend Land' translates as 'the land of evening', but here it means the civilised nations of the West, and implies their decay. A history painter of our times, Kiefer's art may call to mind the holocaust, the division of Germany, the Cold War — all legacies of our moral and political choices.

Within the staged scene in *Lung*, 1983, Boyd Webb makes no attempt to deceive the viewer by concealing details of the studio set. Commonplace materials retain their true identities: the bathtub-boat has a timber underframe which betrays its lack of buoyancy and the 'sea' has wrinkles and tears. Webb uses objects as tokens of the world outside the studio. The titles and meaning of the photograph are oblique. It is a fable about the human condition, but the artist provides no moral.

120. **Mimmo Paladino**, Sirene, vespero. poeta occidentale [Sirens, evening, Western poet], 1986

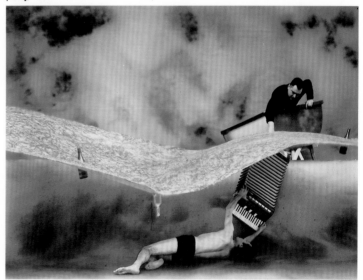

121. **Boyd Webb**, Lung, 1983

73

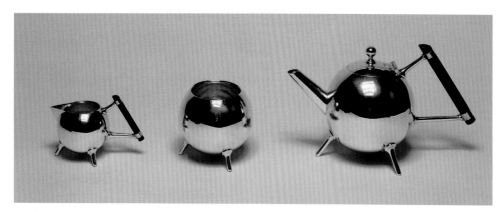

122. **Christopher Dresser**, Teaset, 1880

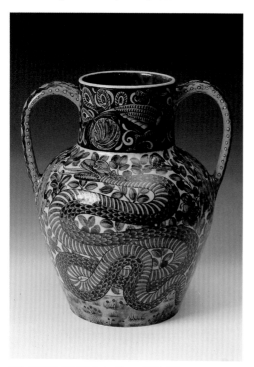

123. **William De Morgan**, Vase, 1888–97

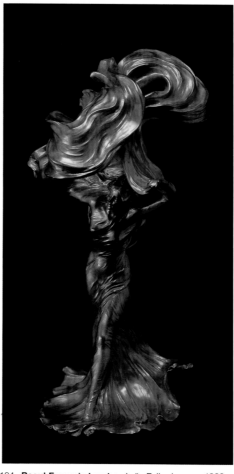

124. **Raoul François Larche** , Loïe Fuller lamp, c.1900

The Applied Arts collection emphasises key works by influential designers. Such is the strikingly simple and forward-looking *Teaset*, 1880, by Dr Christopher Dresser, the first great industrial designer.

Significant periods in design history are another aspect of the collection. Many fine works represent the Arts and Crafts movement. Illustrated is the *Vase*, 1888–97, by ceramist William De Morgan and works by the Art Nouveau designers. These include sculptor Raoul Larche's *Loïe Fuller lamp*, c.1900, and an exquisite *Box*, c.1900, by the Russian court jewellers, Bolin. Modernism had a far-reaching impact on the decorative arts. An early example is the *Fruit basket*, c.1907–12, by Viennese architect Josef Hoffmann.

Later developments include ceramics from the influential British Studio Pottery movement, such as the *Bottle*, c.1979–80, by Lucy Rie. The *Tahiti lamp*, 1981, from Memphis, an Italian design group led by Ettore Sottsass, illustrates the irreverent attitude towards design in the late 1980s.

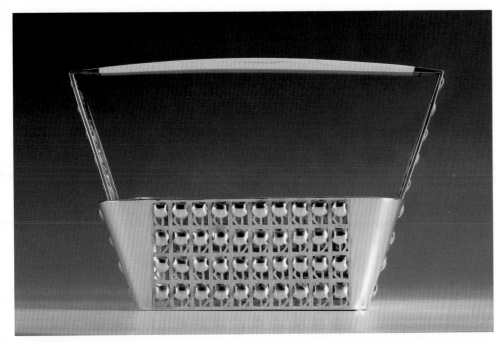

125. **Josef Hoffmann**, Fruit basket, *c.*1907–12

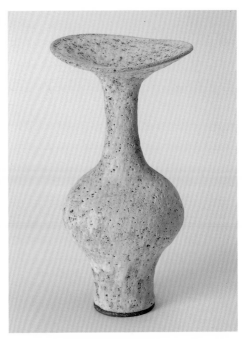

126. **Lucy Rie**, Bottle, *c.*1979–80

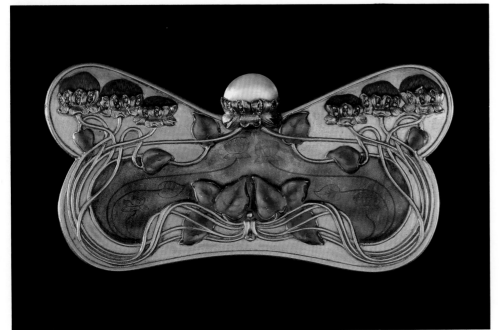

127. **Bolin**, Box, *c.*1900

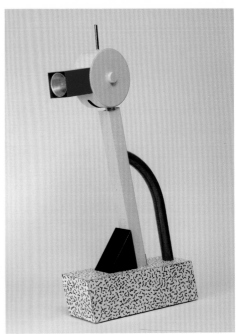

128. **Ettore Sottsass**, Tahiti lamp, 1981

129. **Henri Matisse**, Costume for a mourner from the ballet *The Song of the Nightingale, 1920*

76

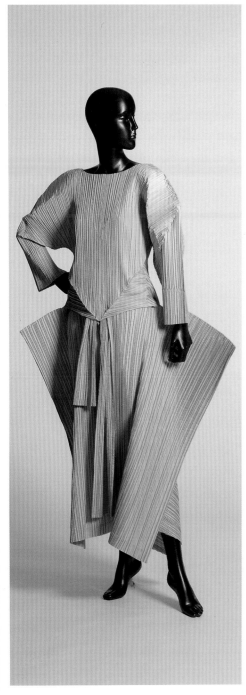

An outstanding group of costumes distinguishes the Theatre Arts collection. Leading artists of the early twentieth century designed many of them for Serge Diaghilev's (and later Colonel W. de Basil's) *Ballets Russes* (Russian Ballet). The collection includes such significant works as the *Costume for a mourner*, 1920, by Henri Matisse. Inspired by Chinese art, Matisse's bold use of appliquéd velvet shapes anticipates his famous paper cut-out compositions by at least twenty years.

Works by the most influential designers of the century are the focus of the Fashion and Textiles collection. Couturier Jeanne Lanvin's bold use of beaded inserts in her drop-waisted *Dress*, 1922, epitomises the Art Deco style. The *Three-piece evening outfit*, 1989, by Issey Miyake, one of the most innovative designers of the century, is the result of an ingenious technique. It involves pleating cloth after, not before, the garments are constructed.

130. **Issey Miyake**, Three-piece evening outfit, 1989

131. **Jeanne Lanvin**, Dress, 1922

List of Illustrations

All works are from the collection of the Australian National Gallery. The artist's name/culture/period is followed by language group and/or country and date of birth; title and date of work; medium; and measurements given in centimetres (height before width before depth).

(Title page)
Ramingining artists
Ramingining, Central Arnhem Land, Northern Territory
The Aboriginal Memorial. 1988
natural pigments on wood; an installation of 200 hollow log coffins, heights 40.0 to 327.0 cm
Purchased with the assistance of funds from Gallery admission charges and commissioned in 1987

1. **Wandjuk Marika**
 Rirratjingu clan
 North East Arnhem Land, Northern Territory. 1927–1987
 Djang'kawu going to Yalangbara. 1986
 natural pigments on eucalyptus bark
 126.5 x 71.5 cm
 Purchased from gallery admission charges 1987
 Reproduced by permission of the Aboriginal Artists' Agency

2. **John Glover**
 England 1767–died Australia 1849
 in Australia from 1851
 The Island of Madeira. 1831
 oil on canvas
 51.0 x 72.0 cm

3. **Abraham Solomon**
 England 1824–1862
 Second Class — the parting: 'Thus part we: rich in sorrow parting poor'. 1854
 oil on canvas
 69.4 x 96.6 cm

4. **David Moore**
 Australia born 1927
 European migrants arriving in Sydney. 1966
 direct positive colour photograph
 20.2 x 30.7 cm

5. **Richard Browne**
 Australia 1776–1824
 The mountain pheasant. 1819
 watercolour, pencil, pen and ink on paper
 33.4 x 27.8 cm

6. **Artist unknown**
 Tasmania
 Sofa. c.1840
 cedar (Toona australus), horsehair upholstery
 115.0 x 210.0 x 56.0 cm

7. **Tommy McRae**
 Kwat Kwat people
 Australia c.1836–1901
 Aborigines, Chinese and a man in European dress. c.1890s
 pen and ink on sketchbook page
 2.2 x 16.2 cm

8. **Benjamin Duterrau**
 Australia 1767–1851
 Mr Robinson's first interview with Timmy. 1840
 oil on canvas
 113.0 x 142.0 cm

9. **Arthur Streeton**
 Australia 1867–1943
 The selector's hut: Whelan on the log. 1890
 oil on canvas
 76.7 x 51.2 cm

10. **Harden S. Melville**
 working Great Britain 1837–1879
 in Australia 1842–1846
 The squatter's hut: news from home. 1850–51
 oil on canvas
 87.8 x 102.1 cm

11. **Artist unknown**
 New South Wales
 Cockatoo roof finial. c.1920
 stoneware
 37.6 x 14.7 x 15.1 cm

12. **George Lambert**
 Australia 1873–1930
 The squatter's daughter. 1923–24
 oil on canvas
 61.4 x 90.2 cm

13. **Artist unknown**
 New South Wales
 Chair. c.1900
 eucalypt, steel, wallaby skin (replacement of original)
 81.0 x 50.0 x 58.5 cm

14. **Russell Drysdale**
 Australia 1912–1981
 The drover's wife. 1945
 oil on canvas
 51.3 x 61.3 cm
 Gift of Mr and Mrs Benno Schmidt

15. **Ludwig Becker**
 Germany 1808–Australia 1861
 in Australia from 1851
 The blow hole on Tasman's Peninsula, Van Diemen's Land. 1851
 watercolour, gum arabic on paper
 17.2 x 24.7 cm

16. **Tom Roberts**
 Australia 1856–1931
 In a corner on the Macintyre. 1895
 oil on canvas
 73.4 x 88.0 cm

17. **Eugene von Guérard**
 Austria 1811–Australia 1901
 in Australia 1852–1882
 North-east view from the northern top of Mt Kosciusko. 1863
 oil on canvas
 66.5 x 116.8 cm

18. **Joseph Lycett**
 England 1774–c.1825
 in Australia 1814–1821
 Beckett's Fall on the River Apsley. 1825
 from Joseph Lycett Views in Australia or New South Wales, and Van Diemen's Land delineated (London: 1825)
 aquatint, etching, hand-coloured on paper
 27.8 x 17.7 cm
 Founding Donor Fund 1984

19. **Grace Cossington Smith**
 Australia 1892–1984
 The Eastern Road, Turramurra. c.1926
 watercolour on paperboard
 40.6 x 33.0 cm
 Bequest of Mervyn Horton 1984

20. **Imants Tillers**
 Australia born 1950
 Mount Analogue. 1988
 oil stick, synthetic polymer paint on 165 canvas boards
 279.0 x 571.0 cm

21. **Jessie Traill**
 Australia 1881–1967
 Goodnight in the gully where the white gums grow. 1922
 aquatint on paper
 49.6 x 46.5 cm

22. **Fred Williams**
 Australia 1927–1982
 Red trees. 1962
 watercolour on paper
 47.2 x 36.4 cm

23. **Max Meldrum**
 Australia 1875–1955
 Family group. 1910–11
 oil on canvas
 217.5 x 140.0 cm

24. **Thomas Glaister**
 in Australia 1850s–1877
 The Moore family. c.1860
 ambrotype, colour dyes
 25.6 x 30.6 cm

25. **Pompey Japanangka Martin**
 Warlpiri people
 Yuendumu, Northern Territory 1932–1989
 Janyinki Jukurrpa. 1986
 synthetic polymer paint on canvas
 198.0 x 121.0 cm
 Purchased from Gallery admission charges 1987

26. **Charles Rodius**
 Germany 1802–England 1860
 in Australia from 1829
 Tooban, ginn or wife of the chief of Shoalhaven tribe. 1834
 lithograph, gouache on paper
 21.6 x 16.4 cm

27. **Thomas Griffiths Wainewright**
 Great Britain 1794–Australia 1847
 in Australia from 1837
 The Cutmear twins, Jane and Lucy. c.1842
 pencil, watercolour on paper
 32.4 x 30.0 cm

28. **Seham Abi-Elias**
 Lebanon born 1964
 in Australia from 1969
 Untitled. 1984
 gelatin silver photograph
 50.8 x 47.8 cm

29. **Hugh Ramsay**
 Australia 1877–1906
 Portrait of Miss Nellie Patterson. 1903
 oil on canvas
 122.0 x 92.0 cm

30. **John Brack**
 Australia born 1920
 Third daughter. 1954
 drypoint on paper
 17.5 x 12.3 cm

31. **Micky Allan**
 Australia born 1944
 Babies. 1976
 from a series of 6 photographs
 gelatin silver photograph, coloured pencil
 11.3 x 11.4 cm

32. **Charles Conder**
 England 1868–1909
 in Australia 1884–1890
 Bronte Beach. 1888
 oil on cardboard
 22.7 x 32.9 cm

33. **Max Dupain**
Australia 1911–1992
The sunbaker. 1937, printed 1970s
gelatin silver photograph
37.7 x 43.2 cm
Gift of the Philip Morris Arts Grant 1982

34. **Harold Cazneaux**
Australia 1878–1953
Sydney surfing. *c.*1928
gelatin silver photograph
26.1 x 28.0 cm

35. **Jack Wunuwun**
Djinang people
Gamerdi, Central Arnhem Land, Northern Territory 1930–1990
Banumbirr the Morning Star. 1987
natural pigments on eucalyptus bark
178.0 x 125.0 cm
Purchased from Gallery admission charges 1987

36. **Narritjin Maymuru**
Manggalili clan
Djarrakpi, North East Arnhem Land, Northern Territory 1922–82
Nyapililngu ancestors at Djarrakpi. *c.*1978
natural pigments on eucalyptus bark
158.0 x 60.0 cm
Purchased from Gallery admission charges 1986
Reproduced by permission of the Aboriginal Artists' Agency

37. **Enraeld Djulabiyanna**
Tiwi people
Bathurst Island, Northern Territory 1895–*c.*1965
Purukuparli and Bima. *c.*1955
natural pigments on ironwood
60.0 and 53.0 cm
Purchased from Gallery admission charges 1985

38. **Tony Tuckson**
Egypt 1921–Australia 1973
in Australia from 1942
White over red on blue. 1971
synthetic polymer paint on composition board
213.4 x 244.0 cm

39. **Ian Fairweather**
Scotland 1891–Australia 1974
in Australia from 1934
Lake, Hangchow. 1941
gouache on paper
42.6 x 47.0 cm

40. **Rover Thomas**
Kukatja/Wangkajunga people
Warmun (Turkey Creek), Western Australia born 1926
Cyclone Tracy. 1991
natural pigments on canvas
183.0 x 168.0

41. **John Olsen**
Australia born 1928
Spring in the You Beaut Country. 1961
oil on composition board
183.0 x 122.0 cm
Gift of Rudy and Ruth Komon 1984

42. **Danila Vassilieff**
Russia 1897–Australia 1958
in Australia 1923–1929 and from 1935
Mechanical man. 1953
Lilydale limestone
48.0 x 20.0 x 24.5 cm

43. **Albert Tucker**
Australia born 1914
Armoured faun attacked by parrots. 1969
synthetic polymer paint on composition board
152.4 x 122.2 cm

44. **Robert Klippel**
Australia born 1920
Untitled. 1955
pencil, collage of cut paper on paper
37.6 x 35.0 cm

45. **Sidney Nolan**
Australia born 1917
Ned Kelly. 1946
enamel on composition board
90.4 x 121.2 cm
Gift of Sunday Reed 1977

46. **Ken Thaiday**
Erub (Darnley Island), Torres Strait born 1950
Beizam (shark); dance mask. 1991
enamel paint on plastic and plywood, steel wire, dyed
feathers, cockatoo feathers
70.0 x 26.0 x 26.0 cm

47. **Ludwig Hirschfeld Mack**
Germany 1893–Australia 1965
in Australia from 1940
Desolation, internment camp, Orange NSW. 1941
woodcut on paper
21.8 x 13.4 cm
Gift of Olive Hirschfeld Mack 1979

48. **Arthur Boyd**
Australia born 1920
The king. 1944
oil on canvas on composition board
87.8 x 111.0 cm
The Arthur Boyd Gift 1975

49. **Ken Unsworth**
Australia born 1931
Untitled. 1987
charcoal on paper
76.2 x 102.3 cm

50. **Richard Bell**
Kamilaroi people
Brisbane, Queensland born 1953
Crisis; what to do about this half-caste thing. 1991
synthetic polymer paint and collage on canvas
180.0 x 250.0 cm

51. **Emily Kame Kngwarreye**
Anmatyerre people
Utopia, Northern Territory born *c.*1910
Ntange Dreaming. 1989
synthetic polymer paint on canvas
135.0 x 122.0 cm

52. **Pala dynasty**
Bangladesh
Vishnu with attendants. early 12th century
phyllite stone
162.5 cm (height)

53. **'Abdullah al-Sayrafi**
Iran died 1342
Page of calligraphy.
ink, opaque watercolor and gold on paper
23.4 x 51.8 cm

54. **Mughal empire**
Gujarat, India
traded to Sulawesi, Indonesia
Heirloom textile (*ma*'a). *c.*1635
handspun cotton, natural dyes and mordants, mordant
painting and batik
102.0 x 534.0 cm
Gift of Mary and Michael Abbott, 1989

55. **Post-Gupta period**
North-west India
The bodhisattva Avalokiteshvara. *c.*700
bronze, silver inlay
50.0 cm (height)

56. **Early Malla period**
Nepal
The bodhisattva Avalokiteshvara. 13th century
gilt copper inlaid with semiprecious stones
47.3 cm (height)

57. **Ming dynasty**
China
Ceremonial hanging and valance. early 17th century
silk, gold thread, natural dyes
295.0 x 203.0 cm (combined)

58. **Kamakura period**
Japan
Prince Shōtoku. *c.*1300
wood gesso and lacquer
47.0 cm (height)
Purchased with the assistance of the Australian National
Gallery Foundation 1991

59. **Kamakura period**
Japan
The Buddha and sixteen protectors. 14th century
ink, colours and gold on silk
115.0 x 60.0 cm

60. **Edo period**
Japan
Kariginu robe for Nō theatre. late 17th century
silk brocade, silk, natural dyes, gold thread
159.0 x 173.0 cm

61. **Ming dynasty**
China
The Goddess Tara. Xuande reign (1426–35)
gilt bronze, pigment
26.6 cm (height)

62. **Paminggir people**
Lampung, Sumatra, Indonesia
Ceremonial hanging (*palepai*). 19th century
cotton, natural dyes, gold ribbon, supplementary weft weave,
appliqué
68.0 x 280.0 cm
Purchased with the assistance of James Mollison 1985

63. **Balinese people**
Bali, Indonesia
**Folio from an illustrated manuscript (*prasi*) with scenes from
the *Ramayana Kakawin* epic.** *c.*early 19th century
ink on paper
37.5 x 46.8 cm

64. **Angkor period**
Cambodia
Male deity. *c.*1010–50
bronze with silver and black glass inlay
50.0 cm (height)

65. **T'ai Daeng people**
Sam Neua region, Laos
Woman's ceremonial skirt (*pha sin*). 19th century
silk, cotton, natural dyes, weft ikat, supplementary weft
weave
94.2 x 67.0 cm (cylinder)

66. **Modang Dayak people**
Kalimantan, Indonesia
End-panel of a funerary vault (*salong or sandong*). late
19th century–early 20th century
wood, conus shell
168.0 x 107.0 cm

67. **Artist unknown**
Ambum Valley, Western Highlands, Papua New Guinea
The Ambum stone. pre-historic period
igneous rock
19.8 x 14.0 x 7.5 cm

68. **Artist unknown**
Lake Sentani, Irian Jaya, Indonesia
Figures from a housepost. 19th century
wood
177.2 x 49.5 x 19.1 cm

69. **Maori people**
Gisborne area, North Island, New Zealand
Ancestor figure (*putokomanawa*) from a housepost. c.1840
wood, pigment
79.7 x 26.5 x 20.2 cm

70. **Artist unknown**
Djenne, Mali
Horse and rider. 14th century
terracotta
66.0 x 38.0 x 12.0 cm

71. **Bamana people**
Mali
Mask. 19th century or earlier
wood
27.7 x 14.0 x 16.0 cm

72. Attributed to **Arowogan**
Yoruba people
Nigeria c.1880 – 1954
Olomoyeye mask of the Epa festival. early 20th century
wood, pigments
145.0 x 49.8 (diameter) cm

73. **Senufo people**
Ivory Coast
Mask. 19th century
wood
27.1 x 14.4 x 8.5 cm

74. **Artist unknown**
Nok, Nigeria
Head and torso. c.325 BC – AD 275
terracotta
51.0 x 25.1 x 21.9 cm

75. **Edo kingdom**
Benin, Nigeria
Plaque representing a sacrificial scene. 16th century
bronze
52.5 x 38.5 x 10.0 cm

76. **Sherbro people**
Sierra Leone
Afro-Portuguese hunting horn (The Drumond Castle
Oliphant). c.1500
ivory
71.0 x 10.5 (diameter) cm

77. **Hopi culture**
Sikyatki, Arizona, United States of America
Bowl with human figure. c.1400 – 1650
earthenware
11.0 x 25.0 (diameter) cm

78. **Kwakiutl people**
British Columbia, Canada
Feast dish. early 20th century
wood, pigments
234.0 cm (length)

79. **Maya culture**
Guatemala
Vase. 8th century
earthenware, pigments
24.0 x 17.0 (diameter) cm

80. **Olmec culture**
Guerrero, Mexico
Mask. c.1200 – 800 BC
jadeite
18.0 x 16.6 x 7.0 cm

81. **Tairona culture**
Colombia
Pendant in the form of a warrior or god. c.1000 – 1500
gold
9.5 x 10.3 x 5.1 cm

82. **Giovanni di Paolo**
Siena, Italy c.1403 – 1483
Crucifixion with donor Jacopo di Bartolomeo. c.1444
tempera, gold leaf on poplar panel
114.2 x 88.5 cm

83. **Artist unknown**
Ferarra, Italy
Madonna of Humility. c.1470
painted wood
65.5 x 47.5 x 21.0 cm

84. **Peter Paul Rubens**
Westphalia (Germany) 1577 – Spanish Netherlands 1640
Self-portrait. 1623
oil on canvas
84.0 x 60.0 cm

85. **Giovanni Domenico Tiepolo**
Venice, Italy 1727 – 1804
Collecting the rent. c.1800
pen and brown ink over black chalk on paper
29.2 x 41.2 cm

86. **William Blake**
Great Britain 1757 – 1827
Jerusalem. Plate 25. 1804 – 20
from *Jerusalem: The emanation of the giant Albion*, by
William Blake (London: William Blake, 1804)
relief etching, watercolour, pen and ink
16.6 x 16.1 cm

87. **Giambattista Tiepolo**
Venice, Italy 1696 – 1770
The marriage allegory of the Cornaro family. c.1750
oil on canvas
343.0 x 170.0 cm

88. **Benjamin West**
United States 1738 – Great Britain 1820
Angel of the Resurrection. 1st State. 1801
from the series *Specimens of Polyantography*, 1803
lithograph
31.4 x 22.8 cm
Felix Man Collection (Special Government Grant 1972)

89. **Honoré Victorin Daumier**
France 1808 – 1879
Emigrants. c.1850
painted plaster
35.0 x 74.2 x 9.2 cm

90. **Honoré Victorin Daumier**
France 1808 – 1879
Baissez le rideau, la farce est jouée [Bring down the curtain,
the farce has been played out].
from *La Caricature*, 1834
lithograph
20.0 x 27.8 cm
Felix Man Collection (Special Government Grant 1972)

91. **Gustave Courbet**
France 1819 – 1877
Study for Les demoiselles au bord de la Seine [Young ladies
on the bank of the Seine]. 1856
oil on canvas
66 0 x 82.0 cm

92. **Claude Monet**
France 1840 – 1926
Haystacks, midday. 1890
oil on canvas
65.6 x 100.6 cm

93. **Julia Margaret Cameron**
India 1815 – Sri Lanka 1879
worked Great Britain, Sri Lanka
English flowers. 1873
albumunen silver photograph
33.2 x 27.4 cm

94. **Edgar Degas**
France 1834 – 1917
Au salon (At the salon). 1879 – 80
monotype
16.2 x 41.2 cm

95. **Claude Monet**
France 1840 – 1926
Waterlilies. c.1917
oil on canvas
181.1 x 201.6 cm

96. **Brassaï**
Hungary 1899 – France 1984
worked France
A prostitute playing Russian billiards, Boulevard
Rochechouart, Montmartre. c.1932, printed 1973
gelatin silver photograph
30.1 x 23.4 cm

97. **Henri de Toulouse-Lautrec**
France 1864 – 1901
La clownesse assise: Mademoiselle Cha-U-Kao [The seated
clown: Miss Cha-U-Kao].
from the suite *Elles* [*Womankind*]. 1896
colour lithograph
52.8 x 40.6 cm

98. **Kasimir Malevich**
Russia 1878 – 1935
Suprematist cup and saucer. c.1925
porcelain
cup: 4.5 x 8.5 x 7.0 cm
saucer: 1.5 x 12.0 (diameter) cm

99. **Kasimir Malevich**
Russia 1878 – 1935
House under construction. 1915
oil on canvas
96.6 x 44.0 cm

100. **Sonia Delaunay**
Russia 1885 – France 1979
La prose du Transsibérien, et de la petite Jehanne de France
[Prose of the trans-Siberian, and of little Jehanne of France].
by Blaise Cendrars (Paris: Éditions des mommes nouveaux,
1913)
colour stencil, letterpress
200.0 x 35.6 cm

101. **René Magritte**
Belgium 1898 – 1967
The lovers. 1928
oil on canvas
54.0 x 73.0 cm

102. **Joan Miró**
Spain 1893 – 1983
also worked in France
Landscape. 1927
oil on canvas
129.9 x 195.5 cm

103. **Pablo Picasso**
Spain 1881 – 1973
worked France
Minotaure aveugle guidé par une fillette dans la nuit [Blind
minotaur led through the night by a little girl]. 1933
from the *Vollard Suite*. 1930 – 37
scraped aquatint and drypoint
24.8 x 34.8 cm

104. **Constantin Brancusi**
Romania 1876 – France 1957
Birds in space. 1931 – 36
black marble, white marble, and reconstructed sandstone
base
193.3 x 47.8 x 47.8 cm; 117.0 x 51.4 x 51.4 cm

105. **David Smith**
United States 1906 – 1965
25 Planes. 1958
stainless steel
350.5 x 169.5 x 40.0 cm

106. **Henri Matisse**
France 1869 – 1954
The abduction of Europa. 1929
oil on canvas
101.2 x 153.2 cm

107. **Paul Outerbridge**
United States 1896 – 1958
Nude lying on a love-seat. c.1936
carbro colour photograph
41.0 x 30.2 cm

108. **Henri Matisse**
France 1869 – 1954
Oceania, the sky. 1946
screenprint on linen
165.0 x 380.0 cm

109. **Henri Matisse**
France 1869 – 1954
The Codomas.
from *Jazz* by Henri Matisse (Paris: Tériade, 1947)
colour stencil
42.2 x 32.8 cm

110. **Fernand Léger**
France 1881 – 1955
Trapeze artists. 1954
oil on canvas
390.6 x 371.6 cm

111. **Erich Heckel**
Germany 1883 – 1970
Männerbildnis (Selbstbildnis) [Portrait of a man (Self-
portrait)]. 1919
colour woodcut, hand painting
46.0 x 32.0 cm
Purchased with the assistance of Tony Berg 1991

112. **Diane Arbus**
United States 1923 – 1971
Boy with a toy grenade in Central Park, New York City.
1962
gelatin silver photograph
20.0 x 17.2 cm
Copyright © Estate of Diane Arbus 1972

113. **Mark Rothko**
Russia 1903 – United States 1970
Brown, black on maroon. 1957
oil on canvas
233.0 x 193.0 cm
© 1992 Kate Rothko-Prizel & Christopher Rothko / ARS New
York

114. **Willem de Kooning**
The Netherlands born 1904
works United States
Woman V. 1952 – 53
oil on canvas
154.5 x 114.5 cm
© 1992 Willem de Kooning / ARS, New York

115. **Jackson Pollock**
United States 1912 – 1956
Blue poles. 1952
oil, enamel and aluminium paint on canvas
212.0 x 489.0 cm
© 1992 Pollock-Krasner Foundation / ARS New York

116. **David Hockney**
Great Britain born 1937
works United States
A diver (17), from the series *Paper Pools*. 1978
coloured paper pulp
184.0 x 444.0 cm
© copyright David Hockney/Tyler Graphics Ltd

117. **Roy Lichtenstein**
United States born 1923
Kitchen stove. 1961 – 62
oil on canvas
172.5 x 173.0 cm

118. **Jasper Johns**
United States born 1930
Gray alphabets. 1968
colour lithograph
152.0 x 106.6 cm

119. **Anselm Kiefer**
Germany born 1945
Twilight of the West. 1989
lead, oil with ash and plaster on canvas
400.0 x 380.0 cm

120. **Mimmo Paladino**
Italy born 1948
Sirene, vespero, poeta occidentale [Sirens, vespers, evening,
Western poet]. 1986
etching, sugarlift, aquatint, drypoint, carborundum and gold
leaf on three sheets
199.5 x 295.5 cm

121. **Boyd Webb**
New Zealand born 1947
working Great Britain
Lung. 1983
direct positive colour photograph
115.0 x 152.0 cm

122. **Christopher Dresser**
Great Britain 1834 – 1904
Teaset. 1880
made by James Dixon & Sons, Birmingham
silver, ebony
teapot: 14.0 x 23.0 x 11.0 cm
sugar bowl: 9.5 x 9.0 x 9.0 cm
milk jug: 7.5 x 11.0 x 6.6 cm
Purchased with the assistance of The Fine Arts Society,
London 1983

123. **William De Morgan**, designer
Great Britain 1839 – 1897
Vase. 1888 – 97
made by William De Morgan & Co., Sands End Pottery,
Fulham, England, 1888 – 97, decorated by Fred Passenger
earthenware, coloured glazes
34.2 x 31.3 x 26.6 cm

124. **Raoul François Larche**, designer
France 1860 – 1912
Loïe Fuller lamp. c.1900
made by Emile Siot-Decauville. Paris
gilded bronze
45.0 x 25.7 cm

125. **Josef Hoffmann**, designer
Austria 1870 – 1956
Fruit basket. c.1907 – 12
made by the Wiener Werkstätte, Vienna, 1903 – 32
silver, ivory
15.6 x 25.6 x 19.0 cm

126. **Lucy Rie**, potter
Austria born 1902
to Great Britain 1938
Bottle. c.1979 – 80
stoneware, pitted white and cream glazes
28.5 x 14.8 cm

127. **Bolin**, jewellers
Russia c.1830 – 1917
Box. c.1900
silver gilt, enamel, diamond, mother of pearl
2.2 x 11.2 x 5.6 cm
Purchased from Private Donor Funds 1989

128. **Ettore Sottsass**, designer
Italy born 1917
Tahiti lamp. 1981
made for Memphis Milano, Milan, est. 1981
metal, wood, laminate, baked enamel
71.0 x 37.0 x 10.0 cm

129. **Henri Matisse**, designer
France 1869 – 1954
Costume for a mourner. 1920
from the ballet *The Song of the Nightingale*
wool felt, cotton, silk, paint, wire
190.0 x 180.0 cm

130. **Issey Miyake**, designer
Japan born 1938
made by Issey Miyake, fashion house, Tokyo, est. 1971
Three-piece evening outfit. 1989
silk, polyester
top: 110.0 cm (length)
skirt: 90.0 cm (length)
trousers: 102.0 cm (length)

131. **Jeanne Lanvin**, designer
France 1867 – 1946
made by Jeanne Lanvin, couture house, Paris, est. c.1905
Dress. 1922
synthetic crepe, glass beads
121.0 cm (length)

The publisher also wishes to thank the following copyright
owners for permission to publish:
© ADAGP, Paris and DACS, London 1992
Sonia Delaunay, René Magritte and Joan Miró
© DACS, London 1992
Erich Heckel, Fernand Léger and Pablo Picasso
© Estate of Ian Fairweather. All rights reserved DACS, London
1992
© Jasper Johns/DACS, London and VAGA, New York 1992
© Roy Lichtenstein/DACS, London 1992
© Succession Henri Matisse/DACS, London 1992
© David Smith/DACS, London and VAGA, New York 1992